CRAXTON'S CATS

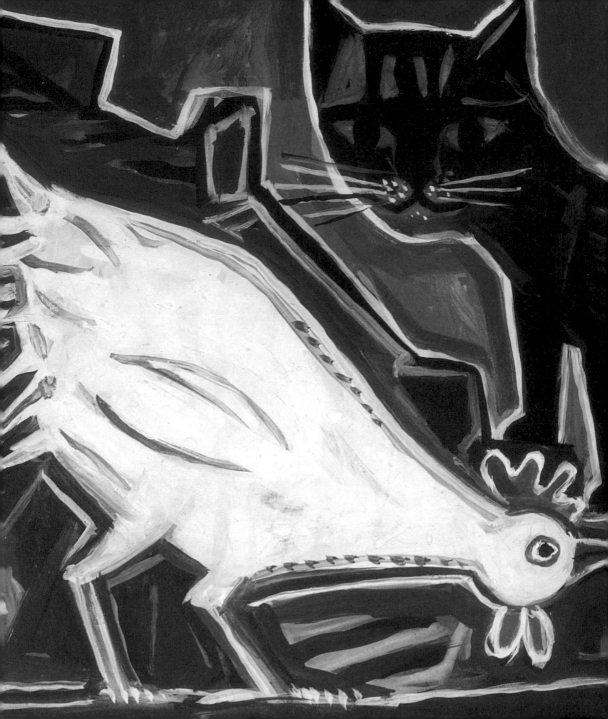

CRAXTON'S CATS

Andrew Lambirth

WITH 87 ILLUSTRATIONS

This book is dedicated to John Craxton and Richard Riley

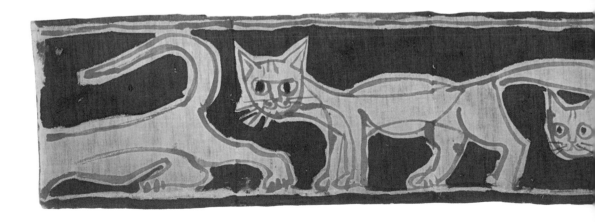

CONTENTS

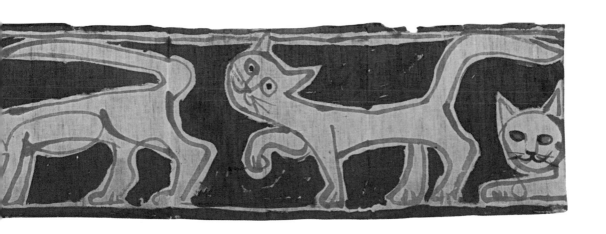

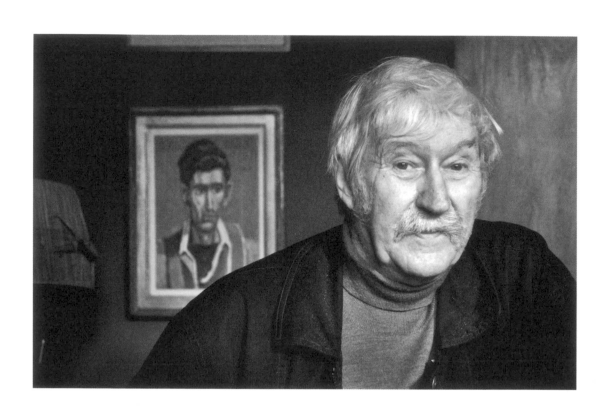

PREFACE

The idea for this book emerged as I got to know John Craxton in the 1990s, and noticed how many cats found their way into his paintings and drawings. John's love of cats was so deeply ingrained that when I suggested putting together a volume dedicated to his depictions of them, he agreed immediately. This was unusual: perhaps out of modesty or self-doubt, he tended to resist the idea of books about his art, but he welcomed the cat project, and so here it is, finally, in book form.

Speaking at his memorial service, Craxton's old friend and collector of his work, David Attenborough, said of him: 'He had a robust sense of humour and an almost unforgivable taste for puns. He produced a series of linocuts for his Christmas card based on that favourite animal of his – the cat. One showed a cat sitting on a column with the caption "cat-a-pillar". There were others – which I will leave to your imagination – captioned "cat-astrophe", "cat-a-pult" and, regrettably, "cat-stration".' Attenborough recognized that cats for Craxton were a source of endless entertainment: his delight in their antics was both infectious and life-enhancing.

John Craxton photographed in London in 2007 by Anne-Katrin Purkiss. In the background is the 1949 portrait of Craxton by Nikos Ghika (1906–1994), one of the artist's closest Greek friends and a very distinguished painter himself.

The pictures in this book range from the 1940s to the end of Craxton's life, and thus offer an indirect account of his stylistic development as well as an informal autobiography. The attentive reader will note that a preponderance of images date from the artist's late period (1990–2009), and this may be because in those years he often found it hard to complete the ambitious figure and landscape compositions he embarked upon. Cat pictures were mostly small-scale and fun to do, so he concentrated on them when he felt blocked on the major works. As a consequence, they have a freshness that frequently eluded him in the larger paintings. Perhaps, too, his imagination had been caught by my suggestion for this book and he proceeded to make a series of cat paintings that could be considered as candidates for inclusion. Certainly, cats were with him to the end: they appear in his last sketchbook, worked on in hospital.

Writing about John and his affectionate understanding of cats has reconnected me to all sorts of memories of the man and the artist, and has helped me to understand his work better. For those who did not previously know his art, I hope this will prove a happy introduction; for established admirers, I trust you will find much to relish. John was the best of company, and I hope that readers will enjoy this excursion into his world.

Andrew Lambirth

Opposite: TIDDLES, c. 2008
Pages 10–11: CAT PLAYING WITH MOUSE, 2006

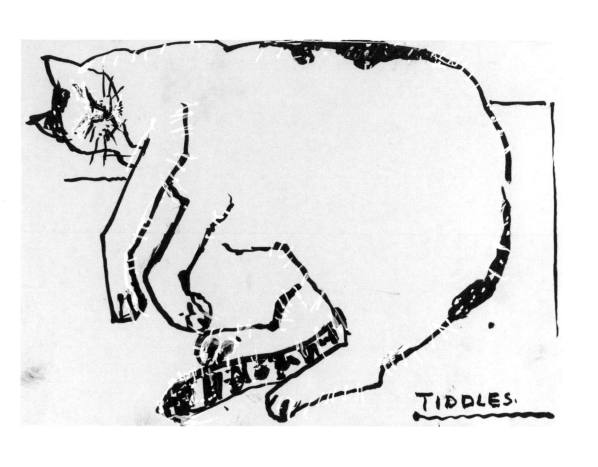

TIDDLES.

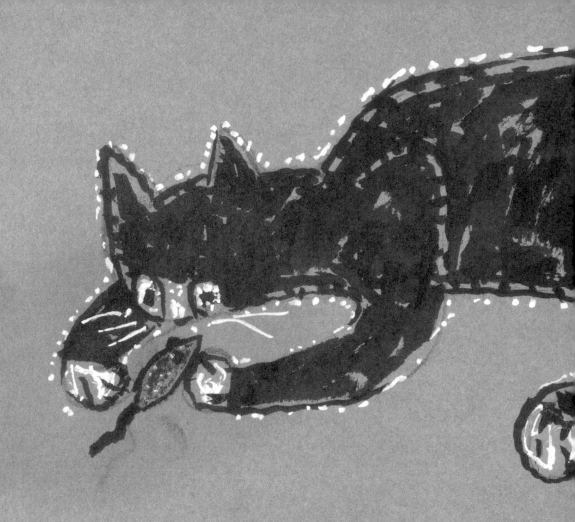

27·7·06·

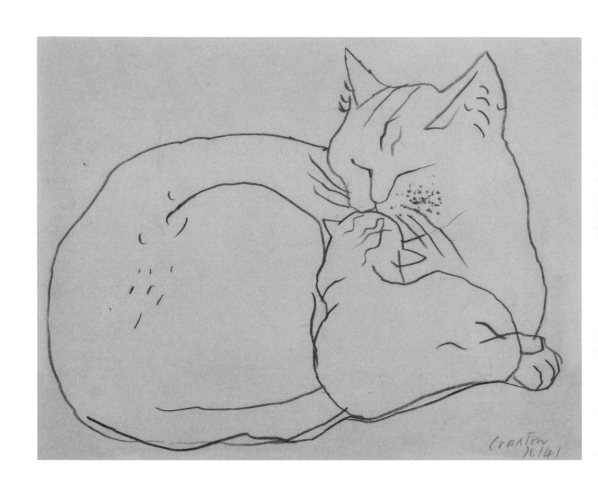

INTRODUCTION

The writer and artist Oswell Blakeston once described cats as the A to Z of the spiritual life. If they were not quite this for John Craxton, they were certainly an index of moods and states of mind, and a splendidly apposite vehicle for his visual and verbal wit. Craxton loved cats and lived with them, on and off, for most of his life. The cat image came readily to mind and hand, whether he was planning a taverna scene in Crete, or doodling during a telephone conversation. Cats permeate his art, weaving their way through his paintings, drawings and prints, bringing humour and mischief to his images as they did to his daily existence. Affectionate and faithless, they were like so many casual lovers, no better than they should be, and gloriously on the make. In many ways, they are a fitting symbol or leitmotif for his own happy-go-lucky life.

John Leith Craxton was born in St John's Wood, London, on 3 October 1922. His father, Harold, was a pianist and musicologist, a professor of the Royal Academy of Music, accompanist to such greats as Pablo Casals, and the first pianist to play Debussy in England. His mother, Essie Faulkner, was the daughter of C. W. Faulkner, who

CAT AND KITTEN, 1941

began in the Christmas card business working in lithography before learning to print in gravure. Best known for its early black-and-white view-cards, real photo cards of actresses, and signed artist cards by Louis Wain, his firm printed a wide variety of card types and games. There was also a family connection with the painter Benjamin West, second president of the Royal Academy of Arts. Music pervaded the Craxtons' lives (John's sister, Janet, became a celebrated oboist), but art publishing was there too, and can it be just a coincidence that part of the family's fortunes was founded on the cat cards of Louis Wain?

From an early age, Craxton loved cats, and although he did not paint and draw them exclusively as Louis Wain did, they became a regular feature of his work and frequently found their way out of sketchbooks into the wider world via his paintings. One of Craxton's most intimate early friends was the painter and textile designer EQ Nicholson, who lived at Alderholt Mill House, near Fordingbridge in Hampshire, a house often drawn by Craxton when he stayed with her in the 1940s. It was there, he said later, that he really hit his stride as an artist, painting the landscape, focusing on cart tracks and fallen trees. Doubtless one of the things that made him feel at home was the fact that EQ had seventeen cats among her livestock. The earliest work in this book is a cat and kitten drawing from 1941 (page 12), which is a strong study of maternity – the mother cat's body surrounding and protecting the kitten, which is having its face washed. It is a statement of content, and if it also subliminally refers to the mother and child in Christian iconography, this is just a hidden reference, not an open declaration. Very likely the drawing was made at Alderholt.

The precocious Craxton, after erratic study at several art schools, soon found success, his style of English romanticism, updated with inflections of Picasso and Miró, proving very popular when he began to exhibit his work in the 1940s. Two exhibitions at the London Gallery (1947 and 1949) confirmed his youthful standing. One of the period's catch-all art categories was Neo-Romanticism, and inevitably Craxton tended to be included in it. He loathed this, utterly rejecting a group mentality that linked him to Michael Ayrton and others with whom he felt he had little in common. His dislike found vivid graphic form in the drawing and inscription he added to his copy of John Piper's 1942 book *British Romantic Artists*. Opposite the title page appears a sinister Craxton drawing of a malformed and grotesque head, a profile portrait of the Man in the Moon, while on the half-title page he has written 'To HELL with' in front of the book's title.

Craxton did, however, admire some of the older artists associated with this tendency, such as Graham Sutherland and Paul Nash, and indeed it was Sutherland who taught the young Craxton to keep a sketchbook and put into it shorthand notes of anything he found visually exciting. And it was with Sutherland, a formative influence who shared his passion for William Blake, that Craxton first travelled through Pembrokeshire in 1943, exploring the natural forms of hill and inlet (Craxton was exempt from war service on health grounds). The United Kingdom was all very well as a source of subjects when foreign travel was impossible, but after the war Craxton craved a hot, dry climate. With another characteristic swipe at the Neo-Romantics, who were always painting moody moonlit scenes of great significance, he proclaimed: 'I wanted to see the sun – I was sick to death of moons.'

TRAVEL: DISCOVERING GREECE

From his earliest years, Craxton liked to go places, and the enforced
isolation of Britain during the Second World War chafed his spirit.
In 1945, as soon as he was able to leave the country, he boarded a ship
bound for the Scilly Isles with the friend of his youth, Lucian Freud.
The pair shared premises in London and were so close in spirit that
they worked on drawings together. Later, their friendship collapsed,
to be replaced by enmity on Freud's part, and melancholy resignation
on Craxton's. Freud tried to airbrush Craxton out of his life, although
each had been an important early influence on the other, and their
friendship had been close and mutually sustaining.

In London the two young artists worked hard and played hard,
relaxing in such Soho pubs as the French and the Swiss, and visiting
nightclubs where they could jitterbug to swing music. Craxton declared
that Freud's drawings in the war years were very bad – all talent but no
technique – so they went to life classes together at Goldsmiths College,
where they discovered conté pencils and Freud learned to draw clean
outlines. Craxton observed wryly that Freud spent the rest of his life
trying to prove that he could draw a hand or a foot because in his earliest
years as an artist he couldn't. Craxton was refreshingly clear-eyed about
Freud. He pointed out that imagination was one of the most important
gifts, and Freud simply did not have it. But for a brief period they were
brothers-in-arms. 'Lucian and I were renegade painters at that time,'
he recalled in conversation with me in 1999, looking back half a century.
'We were painting in a totally different style to anybody.'

In 1946 Craxton visited Greece for the first time, and settled on the island of Poros, where Freud later joined him. Greece was a revelation for Craxton that had all the surprising familiarity of a homecoming. As he often said: 'Greece was more than everything I had imagined and far more than I had expected.' And it was there, with its different pace of existence, that he discovered that some things were more important than making art. Although for the moment London remained his base, he visited Crete for the first time in 1948 and again in 1950, travelling often to Greece in the later 1950s, and first renting the house in the Cretan city of Chania in 1960 that would become his principal home and studio abroad. *Cat on a Monument* (overleaf), from September 1948, was certainly drawn in Greece. The animal has the lean and wily look of a feline accustomed to treating humanity with distrust. Cats tended to gather in archaeological sites, finding shelter among the ruins, and this drawing would seem to refer to such a setting. Semi-wild, these clusters of cats would live on what they could scavenge from leftovers and throw-outs.

In his book *The Dyer's Hand* (1962), W. H. Auden quotes W. B. Yeats: 'The intellect of man is forced to choose / Perfection of the life or of the work', the first two lines of Yeats's poem 'The Choice'. Here is the Craxtonian dilemma: life or art? But then Auden releases us from the cleft stick by pointing out that this is a false opposition, for perfection is possible in neither. However, the choice remains, and it must be said that Craxton often seemed to prefer life. He also preferred to live in a warm climate than in the UK, although he always kept a base in London. In the 1940s and 1950s, he explored Europe, but usually ended up in Greece to

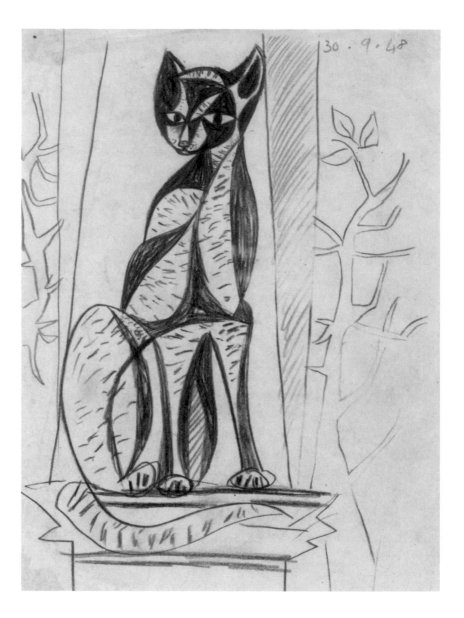

30 · 9 · 48

work. *Still Life with Cat and Child* (page 21), for instance, was probably painted on the island of Hydra while staying with his friend the Greek painter Nikos Ghika in 1959.

Greece matured Craxton as an artist. It brought into focus the various potent influences on the young painter – from Samuel Palmer and El Greco to Poussin, Miró and Picasso – and gave him Greek light to make sense of it all, and Greek colour to seduce his audience. He developed into a linear painter with a clarity of purpose that also included a wilful quality of enigma. The poet and critic Geoffrey Grigson, writing in the first monograph on Craxton, published in 1948, identified 'a singular candidness' and 'an unstuttering intelligence' in the artist, and maintained that 'Delight' was the country he lived in; delight in phenomena, in the visual reality of the world around us. Craxton's art was guided by what David Attenborough, in his introduction to a 1993 Craxton catalogue, has called 'the search for the essential defining image'. When he achieved this in his best paintings, a number of which feature cats, they are charged with a compelling poetic intensity.

In conversation with the artist and writer Gerard Hastings in 1985, Craxton outlined the attractions of his adopted homeland. 'I didn't feel a stranger there and the conditions for work were very favourable. As my first contact with the Mediterranean and the discovery of the action of light, the way light and shadow behave, the arrival in Greece was astonishing. But of course there is never only one reason why anyone does anything or goes anywhere, and it is difficult to unravel it all ... In Greece I found human identities, people within their own environment. This new world fitted me artistically, and suited me

CAT ON A MONUMENT, 1948

socially and financially.' It also offered many opportunities to draw and paint cats, either interacting with people, or regally alone. Their antics and appearance allowed him to indulge his passion for pattern in paintings that wittily capture their spirit.

Bryan Robertson, influential critic and curator, and director of the Whitechapel Gallery from 1952 to 1969, gave Craxton a retrospective exhibition at the gallery in 1967. In the catalogue, Robertson wrote of the artist's 'vigour, astringency and brilliance', and these are qualities that ring out from the best work throughout his career. The references to Miró and Picasso, Ernst and Masson, Graham Sutherland, and of course to Byzantine art, particularly eleventh-century mosaics, were clearly to be seen, but Craxton made something original of his influences, something that was entirely his own. His work was distinguished by a clarity and incisiveness of design, and great vitality. Robertson noted that his colour was 'more tonic, cleaner and fresher, than the prevailing mode of English painting'.

In the Whitechapel exhibition there were six paintings of cats: *Boy, Girl and Cat*, an oil-on-canvas from 1948, lent from a private collection; *Greek Cat*, another oil from 1948, this one belonging to Antony Penrose, the son of Roland Penrose and Lee Miller, Craxton's good friends; *Two Cats* (page 52), a tempera belonging to the photographer Joan Leigh Fermor, wife of Patrick; *Still Life with Cat and Child*, then in the collection of Michael Powell, the film director, and now in the Tate; *A Geometrical Cat*, 1961, in oil on board, also then owned by Michael Powell; and *Two Cats on a Wall*, a tempera painting on board from 1965, then in the collection of Lord and Lady Glenconner. There was also

STILL LIFE WITH CAT AND CHILD, 1959

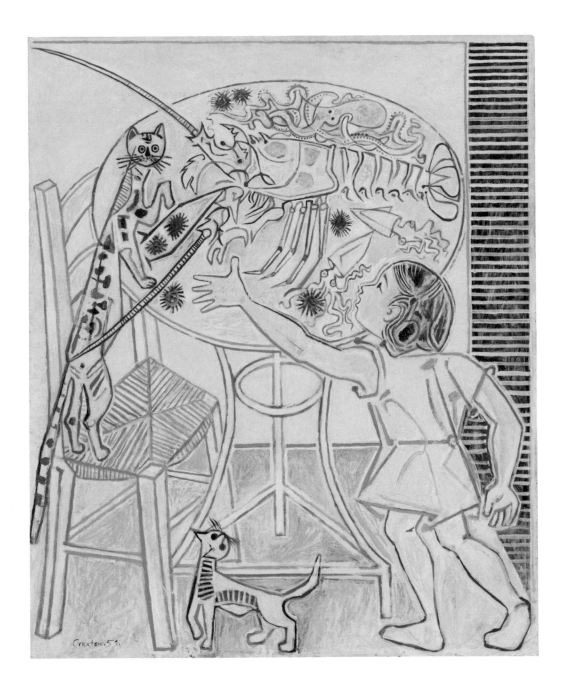

Seated Boy with Cat (*c*. 1953), a black-crayon drawing in the collection of Bristol Museum & Art Gallery. This strong feline presence clearly indicates the seriousness with which Craxton (and Robertson) took his cat pictures.

In the catalogue for his Whitechapel exhibition, Craxton wrote of how stimulated he was by Greece, 'by the country and the people because of mutual sympathy, physical well-being, cheapness, and the way in which my personal philosophy seems to tie up so much more with Greek life than anywhere else'. Although he always felt himself to be an English painter, albeit an absentee one, he was absorbed in the life of modern Greece. And despite his keen appreciation of the culture and monuments of ancient Greece, it was the daily life in Poros, Athens, Hydra or Crete that so deeply appealed to him. He said that he painted out of 'a collision of the senses', and tried to make new myths out of contemporary reality.

Craxton's work is characterized by an emphatic use of line (drawing always remained at the heart of his practice), partly because what he sought above all was precision of statement. He aimed for a balance in his paintings between colour, flatness and formalization, with sensuality and depth of feeling. The best of his landscapes and figure paintings achieve this, but very often his smaller, more spontaneous studies are the most engaging and successful. And this is where his cat pictures score high. They have an immediacy that is wholly natural and integral.

When I interviewed Craxton for the National Sound Archive in 1998 and 1999, one of his many memorable remarks was: 'Painting is a very strange art because it's a combination of emotional intuition and

John Craxton painting *Two Cats* (page 53), 1956

learning and wisdom and experience.' This was really a self-portrait in miniature, for these were his own personal characteristics. He thought painting should be succinct, like poetry, and the image strengthened by selection, going for the essence. This directness was, however, usually qualified by further consideration, hence his sometimes alarming habit of repainting. 'The whole of art is exposition and correction,' he insisted.

Craxton knew a great deal about art and its history, had looked at a great many paintings, and had very firm opinions about his favourite artists. He was genuinely learned in a haphazard way, but wore his scholarship lightly. In addition to the sixpenny prints he bought as a young man on the Charing Cross Road, by such artists as Dürer, Altdorfer and Hans Baldung Grien, he also found a book of engravings of Italian peasants in Heffers bookshop in Cambridge. These provided insight and inspiration for his paintings. He told me, late in life, that he made use of these sources far more than anything he had seen by Picasso or Miró.

Craxton was an expert on a number of artists, some well known (El Greco, Blake), some more obscure, such as Hercules Seghers, who influenced Rembrandt. His knowledge of Blake enabled him to make the kind of find that collectors dream about, when one day he was sifting through boxes of mixed prints in a shop on Marylebone High Street and discovered a Blake painting. He would later sell it to the Tate Gallery, which enabled him to increase his holding in the Craxton Studios, the family home, by buying out one of his brothers.

One of Craxton's closest friends from the 1950s was the prima ballerina Margot Fonteyn, and there was even talk of them marrying – if either had had any money. (Fonteyn later married the Panamanian

lawyer, diplomat and journalist Roberto Arias.) Although by inclination more drawn to men, Craxton also had female lovers, Fonteyn among them, and he was deeply attached to her. There is a black-and-white photo of John and Margot taken in 1951 by the celebrity photographer Baron, onto which the artisthas drawn a black cat and a sylvan stage set in black ink – the black cat for luck (see overleaf). The allusion was to his designs for Ravel's ballet *Daphnis and Chloe*, commissioned by the choreographer Frederick Ashton as a vehicle for Fonteyn, and put on that year at Covent Garden.

Painting and drawing cats was, to some extent, light relief for Craxton, but this was an artist who worked primarily for pleasure, so the whole range of his artistic activity was there to be relished and enjoyed: firstly by himself, then by his audience. His main subject was landscape and figures in landscape, but the inhabited landscape contained not only people but animals as well. Shepherds and goats appeared frequently, and so did cats. Craxton was most definitely a cat person; there are very few dogs in his pictures. As Winston Churchill (who Craxton met in Crete in 1960 and had dinner with) said: 'Dogs look up to us. Cats look down on us.' That superciliousness is well captured in several of the pictures in this book, particularly the one on page 87.

Craxton liked to work when he was in the mood for it, but he was also happy to allow himself to be distracted or led astray. As his partner Richard Riley pointed out in a long interview I conducted with him in April 2021: 'If Lady Thing rang at half past nine in the morning and said, "Oh Johnny I need an extra man for lunch, could you come?", he'd say, "Oh, of course." Or he'd go off to the Opera House if somebody

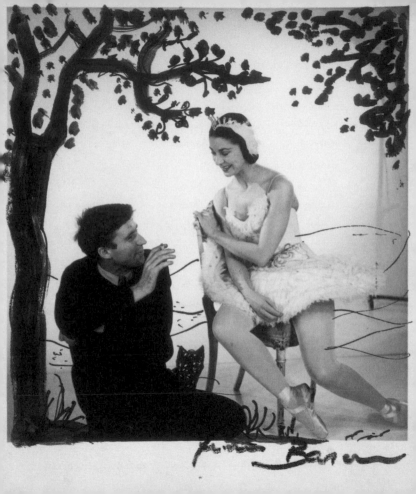

called. He didn't want to be tied down all the time.' Life was for living, and in some respects life was more important than art. You won't find many artists thinking that. For them art is paramount, if not sacred, and everything (health, personal relationships, finances) will be sacrificed to further its cause. John Craxton, consummate artist though he could be, preferred to keep a sense of proportion about his art, and would often spend the day with friends or visiting an exhibition or an old church. (He said he would have loved to have been an architect.)

That is one of the key reasons why Craxton is not more famous or more widely known: he never promoted himself or pursued a career in art with the kind of ruthlessness that wins prizes and scholarships, or attracts competitive dealers, international sales and an endless round of museum retrospectives. Craxton remained elusive. I remember regularly meeting people, even art lovers and students, during the twenty years I knew him who actually thought he was already dead, because he was so invisible in the country of his birth. Of course, he lived much of the time in Crete, and, when he was in London, did not make the headlines, but he was still active as an artist, just not in the public eye. What a contrast to his old sparring partner, Lucian Freud, who managed to get written about extensively for his aristocratic sitters and unconventional private life. But then, as a grandson of Sigmund, he was boosted into society and rapidly became a darling of the Establishment.

Craxton's attitude was very different. Although extremely well connected himself, he was not really interested in self-promotion. And he had a somewhat conflicted relationship with his art. Although a fluent draughtsman, painting was often a long and arduous process

John Craxton and Margot Fonteyn, 1951

27

for him. As Riley says: 'He would get on with things once he got into the right frame of mind, but they were always unfinished. He never quite completed anything. It was only in the eighties when Christopher Hull [his dealer in this period] materialized, and when John had by that stage gone back to Greece, that he seemed to have a spurt – for want of a better way of putting it.' Craxton was frequently filled with doubt and indecision about his painting, and later this would develop into a painful and intensely frustrating case of artist's block. Ironically, he never seemed to be short of ideas for pictures, but he found it increasingly difficult to realize them.

Riley recalls an example of this irresolute behaviour when he began sharing Craxton's studio in Willesden, north-west London: 'When I was first part of the equation [in the mid-1970s] he'd be working on that *Five Goats* picture, which he'd done another version of. I'd go off to work in the morning and by the time I came back it was a completely different colour. "Oh I quite like that," I'd say, "oh, that works." But by the next evening it had changed again. [As time went on] it must have been the thickness of a brick, there were so many layers of paint on it. It went to Japan to be exhibited, and when it came back, it lay there [in the studio] for quite a while. I said, "John, if you're not happy with it, get rid of it." In the end we burnt it.'

CRAXTON AND RILEY

The life-changing encounter between the two men had taken place in London in 1973, when Riley was twenty-four and Craxton was fifty.

'We met in a cinema, a rather low dive where nobody went to see a film. It was in Victoria and is long gone. It was a most bizarre place, but it had its moments. I had friends who cried the weekend it was knocked down, because it had been their life. About three months later, I moved into John's terrible studio in Willesden. It was a tip. In those days John would go off and do all sorts of things in the evening, leaving me on my own – on my first birthday together I was left with a cheese plant! In Willesden there were two big rooms, with high ceilings, nice mouldings, late Victorian, with a garden at the back, but no cat. John had a big ground-floor room which had French windows into the garden. That's where he painted. And there was a big room above. It was full of every kind of detritus that you can imagine. I tidied it up a little bit, but John never liked it being too tidy. Park Avenue [the studio's address] sounds grand, but it wasn't.'

I asked Riley about the first cat he remembers in the life he shared with Craxton. By this time, they had moved to the Craxton Studios, the family home on Kidderpore Avenue, north London, which had been turned into a rehearsal studio for musicians. John had always had a room there, and this now became Richard's base, even when John was away. 'Oh, there was a monster of a cat that John's sister had and that lived on the top floor. It was black. There had always been a cat in the house but this one on the top floor never came downstairs. It was a kind of nervous wreck really, I think. If ever one went up the staircase, it would sit on the top landing and hiss at you. John used to hiss back. It wasn't a nice cat, but it lived for a very long time; it lived to be about twenty-one.

'Before Janet died [in 1981] and before John's mother died [in 1977], there was another cat that moved in on us. The undercroft of St Luke's,

Kidderpore Avenue, was home to several feral cats. A black kitten from this pack found its way into the garden of No. 14 [the Craxton Studios]. John put out titbits to coax it in. John's mother said that it could not come in as Janet had a cat already. One afternoon it did find its way in and settled on John's mother's knee. She woke from her nap and said: "Oh how sweet, it's sleeping on my lap." That was it, the kitten was in. John and I named it Smudge. He adopted us really.

'Some time later, Janet took him off to the vet to be neutered. The next morning she came down in such a state, saying, "That cat

John Craxton with Richard Riley, revealed as a Green Man of the woods.

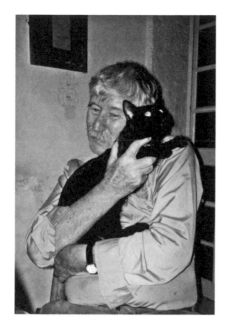

has just peed all over my duvet!" (She was under it at the time.) I said, "Well, what do you expect? You took away his manhood!" But that was a lovely cat, delightful. John did a painting for my birthday in 1978 of Smudge begging at the table [page 79]. It looks just like him.'

Craxton never set out to have a cat as a pet; instead, he tended to adopt them. Or else they simply found him, and stayed. They would be named something traditional like Tiddles or Smudge. Wherever he was, in London or in Greece, he had a cat. He liked the fact that cats could take care of themselves, and were good at cadging meals. As Riley puts

The love of a good cat; jump, kitty, jump!

it: 'They're free agents, they come and go. [John] wasn't around enough to be able to look after cats every day, but there were people in the house [in London] who would make sure puss was fed and watered. It was as simple as that.' As Geoffrey Household observed in his 1939 novel *Rogue Male*: 'What cats most appreciate in a human being is not the ability to produce food which they take for granted but his or her entertainment value.' And Craxton was very good value indeed.

A similar arrangement prevailed in Crete, as Riley describes: 'John always had cats in residence in Chania. When he was away neighbours fed them, and anyway cats can fend for themselves. Going back to Chania after a long absence, we returned late at night. Taking a taxi to the harbour, as we arrived so did puss. The cat ran ahead and John pretended to hide and wait. Puss reappeared a few seconds later annoyed that we were keeping her waiting. Much amusement.'

Riley's own life included cats right from the start. 'Growing up on a farm, cats were always around. We had probably at least eight or nine, encouraged by my mother who adored them. Many years later at her funeral the vicar spoke of how she had been a loving and kindly countrywoman – and how she had loved cats. As we left the church and walked into the churchyard, there were cats everywhere. My partner at that time remembered how spooky it was.'

Cats, acutely self-conscious, hate to be stared at, much preferring to be off about their own business. Craxton did portray cats curled up in a basket, or sitting with paws tucked up, no doubt purring. But Riley is of the opinion that most of his cat pictures were done from memory rather than direct observation. Craxton was so familiar

PUSSY LOOKING INQUISITIVE, 1990s

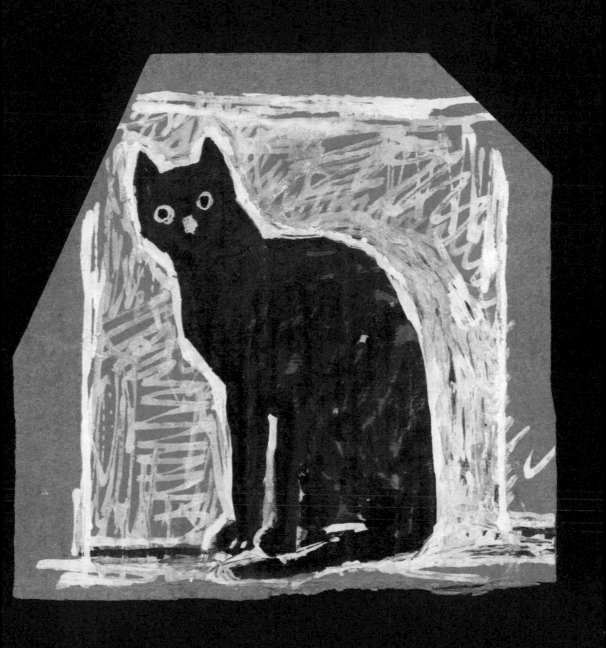

with the vocabulary of cat moves, gestures and stances that he could capture them with utter conviction in a few strokes of the pen or brush. His habitual practice was to work from memory in the studio, whether painting animals, people or places, and although he did make direct studies from life, of landscape, for instance, he also took a lot of photographs. These were snaps really and were used as aides-memoire, rather like a sketchbook.

Craxton was never reliant on photos, however: to the end of his life, drawing was much more important. Riley recalls: 'He always carried a little pad around with him and he was always noting something or other, whether it be tourists, a cat or some other creature. It could have been a snail or a lobster waiting to be boiled, appearing in between phone numbers, notes such as "Opera House 6.30", and so on.' Drawings in the sketchbook might have been done from life – but they might also have been remembered or invented. Riley thinks they were a mixture.

Riley and Craxton's life together was not a settled one. Even when he couldn't go to Greece, Craxton liked to travel and would take off on his motorbike, alone more often than not, sometimes touring Britain, sometimes taking a ferry for the Continent. One memorable trip both men took on the motorbike was to Amsterdam, and from there to Cologne, Bonn and the Augustusburg Palace at Brühl with its magnificent staircase by Balthasar Neumann, then home via Aachen. Riley says he always felt completely safe on the back of the bike. 'I never felt uncomfortable at all.' Riley loves motorbikes and owned a small Honda at one point but never really got the most out of it. He decided

Clockwise from top left: Domestic bliss; Tiddles on a chair; brotherly love; Tiddles in the chaplet; relaxing; cat on a pedestal.

he made a better passenger. 'John was very confident on the motorbike, partly perhaps because he'd had bicycles as a child.'

Craxton had learnt to ride a motorbike from his friend Spud Murphy, a minor criminal who also knew Lucian Freud. Spud, who was Craxton's lover for a time, had a BSA Bantam, on which he taught Craxton to ride. As soon as he passed his test, Craxton bought a Triumph Tiger 650, which he loved to ride in black leathers. This bike was stolen in London, but subsequently recovered, and much cherished. In 1985, with some of the money earned from successful exhibitions at the Christopher Hull Gallery, Craxton bought a Moto Guzzi, which he proceeded to drive across Europe. 'Stopping at fleshpots and various other places of interest en route,' as Riley puts it, he eventually arrived in Crete. Prior to the Moto Guzzi's arrival, Craxton had ridden a battered old 1950s BMW in Greece, but it had gone beyond safe use. He kept it, however, and a few years ago Riley had it shipped back to England, where it is being slowly and lovingly restored.

'We weren't together all the time,' Riley observes matter-of-factly. Perhaps this was the reason they stayed partners: there was enough air and freedom in their relationship to allow it to flourish. In effect, Riley had to earn his living in England, so that was where they saw most of each other. In the early days of their relationship there was a period in Scotland, where Craxton was working on the cartoon for a tapestry. Commissioned by the new University of Stirling, the tapestry is called *Landscape with the Elements*, and is a typically evocative Craxton composition of land and water, sun and moon, with a central passage a little like a Cretan gorge (a favourite motif), with a fig tree or two and plenty of those curling,

spear-leaved plants he loved to draw. It was woven by the Edinburgh Tapestry Company at Dovecot Studios to mark the tenure of the scientist T. L. Cottrell, the university's first vice chancellor.

Riley recalls: 'John was up in Edinburgh for a considerable time [almost three years, 1973 to 1976], and I used to commute up there, backwards and forwards. I'd left my job in the West End in antiques/jewellery (I've been in retail all my life). We had a tiny flat in Scotland and I don't know how we managed but John decorated a harpsichord in the middle of the little sitting room. That's where he did those drawings of fusiliers who came to call. In those days, Edinburgh and the surrounding area was a veritable treasure house of antique markets and shops, but I had no money to buy those things.' Nor was there a cat in the Scottish lair, although that would not have prevented Craxton from drawing one. Indeed, there are some splendid cat pictures from the 1970s, including the hilariously disreputable *Dancing Cats* (page 70) and the intricate linear patterning of *Cat and Goldfish* (page 74).

In 1967, the Regime of the Colonels (or Greek junta) began, and a petty official whom Craxton had unwisely made an enemy of now had more power and took pleasure in having him deported. Expulsion from the land he loved was bitter, and difficult to bear. Craxton needed to distract himself. The early 1970s became a period of exile and travel: Kenya, Tunisia, Morocco, Lanzarote. In Africa he met big cats, and made several pictures of lions. Once his banishment from Greece had been rescinded (the colonels fell from power in 1974), Crete was once again the lodestar of Craxton's life. He settled back into the old Venetian house in Chania with a view of the harbour from the studio terrace.

BACK IN CRETE

Riley remembers that epoch well: 'The first time I went to Crete would have been in May 1977. John was already there. His dossier had been cleansed and he had permission to go back to Greece. I went out for a couple of weeks: to Poros and Hydra, and then on to Crete. I said the studio [in London] was chaotic – it was even more chaotic out there. He'd had the house in Chania since 1961. He owned it. Various people sort of kept an eye on it when he wasn't there, but it needed a lot of attention. Nothing worked: the roof leaked, it was pretty grim. I can't say that I did very much [to change that] when I was there. It never got fixed when John was alive. Even the roof wasn't properly finished. He'd get distracted. He didn't want to be there all the time. The problem with John was that he'd stand over people and say, "No I don't want it quite like that. No, that moulding's wrong! No, it needs to be a little bit more off-centre." He was not easy. I'm one of the few people that he didn't drive mad.'

Although Riley did fly over to stay with Craxton in Crete from time to time, it wasn't the usual pattern of their existence. 'I only started to live there for extended periods in about 2002/2003. John would go out maybe for the winter, but I couldn't – I had to work! I had to earn a crust somewhere along the line. And I'd keep things together at this end [living in the Craxton Studios]. Although John and I went in different directions I was always around to pick up the pieces of some mess that had been left there. At one point, I'd moved out of London and was in the north, but I'd commute backwards

CAT AND GREEK MILITARY POLICEMAN, 1980

and forwards, deal with John's post, with bills, things like that. I was a sort of housekeeper.'

In Greece, there are cats everywhere. Several of Craxton's friends kept cats, sometimes in surprisingly large numbers. 'Joan Leigh Fermor was a great cat person – she adored them,' remembers Riley. 'She probably had about twenty or thirty of them wandering around the house at Kardamyli [on the Greek mainland].' John and Joan may have loved cats, but Joan's husband, Patrick Leigh Fermor, had mixed feelings about them. He famously called them 'interior desecrators and downholsterers'. When I asked Riley about Craxton's favourite animals, I wondered if goats (an oft-used Craxton motif) were high on the list. Evidently, he did like goats, but only after he discovered Greece. Riley comments: 'Cats were very much part of John's life. I think he loved the fact that a cat came and curled up on your knee, or snuggled up to you. Cats were humans: they got round you. In those early childhood days, when John spent time with farming friends and relations, it was another form of escapism for him. There were cats there too. I don't think he liked school very much, he just wanted to be his own free agent, and you could be that in the country.'

I wondered if that was one of the chief attractions of living in Greece. 'Well, yes, and the pace of life was so much less stressful. He could go for days, wandering up to the market in Chania, having peculiar dishes to eat, gossiping, and work just didn't get done.' This was Craxton the hedonist, enjoying life to the full. 'Absolutely,' says Riley, 'and I rather agree with him in many ways. And I wish I could have been more a part of that.'

THE LAST YEARS

Towards the end of his life, Craxton made many cat drawings, including a number of doodles while talking on the telephone. By this point, long conversations on the landline had to some extent taken the place of getting out and about as much as he used to. The late works reproduced here are a selection of the drawings he considered good enough to keep, or that were salvaged and preserved by Richard Riley.

Craxton's conversation was salted with the puns to which he was addicted, some very funny, some excruciating in their tortuous obviousness. He even claimed to have invented his own language – Anglo-Craxton – and wittily referred to his late-onset painter's block as 'procraxtonation'. Puns, along with street songs and slang, were very much a tool or strategy of Modernist writing, particularly evident in the works of T. S. Eliot and James Joyce. The profundity of puns was recognized and accepted: punning and parody were funny but also serious. In this, Craxton was very much a creature of his time. He readily admitted to the charge of frivolity, but his lightness of touch was always balanced by serious enthusiasm for music, art and architecture. He was a dedicated bon viveur, but his skills as a raconteur and imparter of knowledge provided a sheet anchor and made him a companion always worth listening to and learning from.

Craxton's cat pictures ran the gamut of emotions from self-confident to fearful: from the self-possessed pampered house guest regally reclining on her favourite cushion, to the tiniest ball-of-fluff kitten frightened of a mouse. In between are the great inquisitors: cats sticking

their noses into anything of interest, while at the same time trying to curb the human heresy of disobedience. (Cats always think we are there merely to serve them. In his *Essays*, Montaigne wrote: 'When I play with my cat, who knows but that she regards me more as a plaything than I do her?') Some of Craxton's most affecting images are of young cats investigating their surroundings: sniffing at insects, for instance, a snail or a beetle. These pictures feel as if they were close to his heart, and it's no surprise to find that he gave an oil-on-board version of the cat and the snail to Margot Fonteyn in 1965.

There is quite a range of imagery here, from the early Gothic (*Cat with Ball of Wool*, 1942; page 55), to the wonderfully primitive *Dancing Cats* (1970s), full of joie de vivre, to the Modernist simplifications and beguiling sprung rhythm of *Pink Cat Prowling* (2008; pages 130–31). Craxton's admiration for Picasso is evident in the way he draws the ears of some of his cats on the top or side of the head – for example, *Cat and Mouse* (pages 44–45), *Cat Hunting* (page 114) and the deliciously plump but sleek *Cat and Ball* (pages 116–17), all made between 2006 and 2007 – thus eliding profile and full-face in a typical Cubist strategy. It is very effective and more humorous than disturbing. Among the last cat pictures, two of the most compelling are a pair of studies of Craxton's London cat Tiddles (pages 9 and 48), sprawling at his ease, his large body relaxed and expansive, well-fed and comfortable, a far cry from some of the half-starved harbour cats of Crete.

You can see the pleasure Craxton took in the spontaneity of his drawings, which are of course his first thoughts. It was when these came to be transferred to board or canvas that some degree of aridity and even

stiltedness could begin to appear. The late large paintings, in which a cat is hidden in a tree with a bird somewhere about, are reminiscent of children's puzzle pictures. Can you see the cat hidden in the vase? Or find the cat hiding in a sea of owls? Riley comments: 'Some of the late work gets painful – you can almost see the pain in the cat's expression, an arthritic cat, almost. John went through agony with his Arthur Wrongness, as he called his arthritis.'

Craxton lived on the edge of a world of high bohemia, which could be distracting, and he liked the good things in life. But he was by no means simply a socialite or playboy; and if somewhat lacking in conventional ambition, he was an artist to his fingertips, by temperament and sensibility. For all his gregariousness, he was also the cat who walked by himself. He was deeply individual, an independent artist who painted precisely what he wanted to, even when he undertook a commission.

An upsetting burglary in Crete in 1994 seriously dented his trust in the island and his enjoyment of living there, for two of his favourite and most valuable pictures were stolen: a large Miró pochoir – a hand-coloured lithograph – and a Graham Sutherland gouache, *Entrance to a Lane*, dedicated to him by the artist. (This was a version of the famous 1939 painting of that name in the Tate.) Also some Arcimboldo prints. Ironically, none of his own work was taken.

The early friendship with Lucian Freud had by now totally disintegrated. Richard Riley recalls seeing Freud, in 2008 or 2009, on his home territory in Kensington, but neither man paused to exchange greetings. Back at Kidderpore Avenue, Riley reported to Craxton:

Overleaf: CAT AND MOUSE, 2006/07

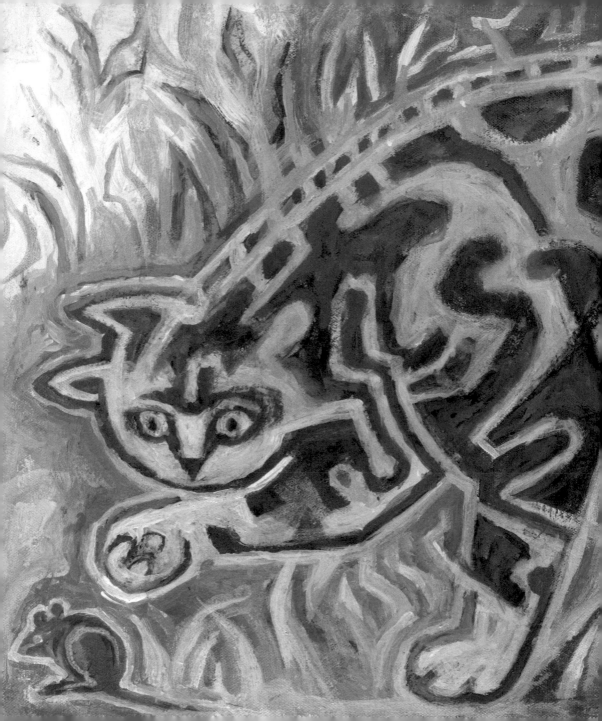

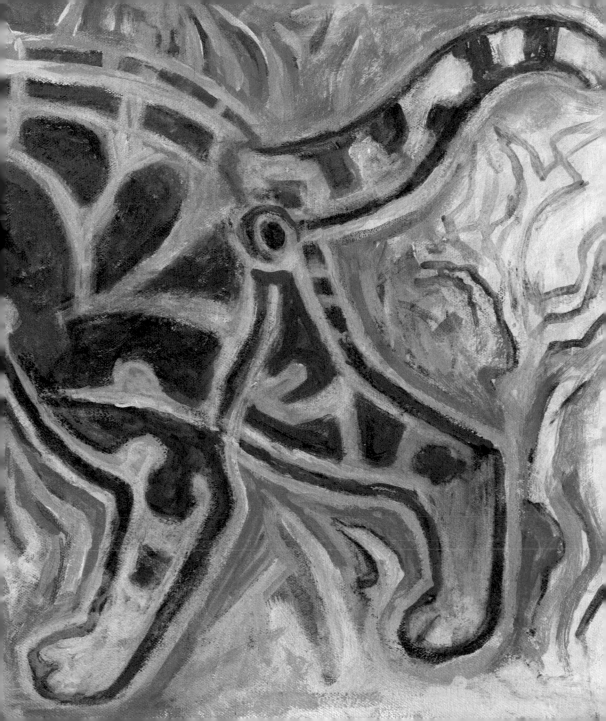

'I saw someone you know in Kensington Church Street today.' 'Must have been a rat,' was the off-hand reply.

Sadly the two men had moved too far apart for reconciliation, and it seems that Freud had grown to resent the fact that Craxton had for a while been more successful and better known as an artist. Indeed, Craxton had been something like an older brother in art to Freud, although actually only two months older. But Freud's competitive nature had eroded the fraternity. One story illustrates rather well the temperamental differences between them. As friends and colleagues they had exchanged paintings in the early years, and as they grew older, these works became increasingly valuable.

One day Freud bumped into Craxton in the street and asked his permission to sell a painting acquired in this way, in order to settle a gambling debt. Craxton said, 'Of course, it's yours to do with as you like.' Some years later, Craxton in turn found himself in financial straits and sold some drawings by Freud, to which his former friend took violent exception. The resulting bad feeling between them was a source of sadness to Craxton. I remember him asking rhetorically, 'Whatever happened to that lovely boy?'

It became something of a tradition for Craxton to make cat cards for Christmas or the New Year (shades of C. W. Faulkner), and these extended through the decades from the 1950s to the 1980s and beyond. 'The only card that actually arrived for Christmas', recalls Riley, 'was the very last one, *I am with Child* [2008, and not a cat picture]. I was rushing about to get them printed and that year every one went out before Christmas. Sometimes they could be posted in February or March. In the earlier days,

John's mother used some and Janet used some. They were very popular.' A number of these memorable images are illustrated here.

One final cat played an important role in the Craxton household. Riley takes up the story:

'Tiddles was huge. When he was spread out he'd be almost thirty inches from head to tail. He was a big lumbering thing. In 2005 we had decided to spend much of the winter in Crete. Just before departure, Jane Astor [daughter of the politician and writer Michael Astor], who was a very good friend to us both, called me to say she was not well. The following May, [the composer and broadcaster] Michael Berkeley called us in Crete to say that she had died at the horribly young age of fifty-six. We could not return for the funeral, but some months later [in London] her stepmother, Judy Astor, came to tea. We sat in the garden at Kidderpore Avenue and talked about Jane. Judy had come to give me a keepsake in Jane's memory. I thanked her and said I would much rather she was still alive.

'When Judy was leaving, I opened the front door and a huge white cat appeared. I said, as it sauntered in, that this was Jane's spirit. Where had it come from? Nobody knew. It came and went as it pleased. John and I called it Tiddles. A few weeks later it stopped coming to the house, in much the same sudden way it had arrived. The following spring, and the return of lighter evenings, I was in the Kidderpore kitchen talking to a friend on the phone about cats. Suddenly Tiddles appeared on the windowsill. It was the anniversary of Jane's death.'

On 17 November 2009, John Craxton died after a long illness. Richard Riley again: 'A few days later I had organized his cremation

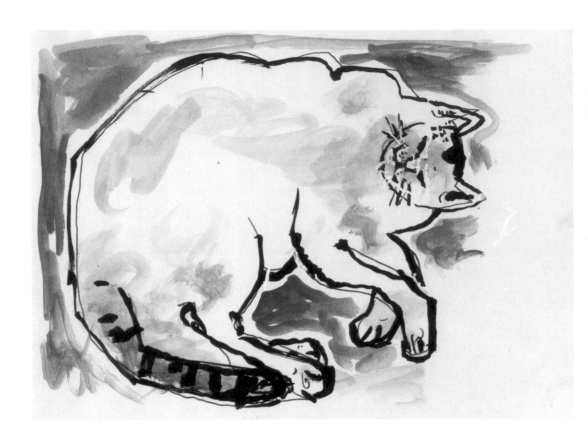

at Golders Green for 9.30 am, the first slot. The hearse arrived and I enquired where the chaplet from the RA was. "No wreath, sir." "Oh well, too late now." A few friends gathered and we sent him on his way. I joined the ladies who lunch and then returned to sleep. I woke to the doorbell going. I leant out of the upstairs window and a bloke said, "I have a wreath for you." I replied: "You're a bit late, guv." Returning with the chaplet, I put it on the table in the kitchen and turned to flick the kettle switch. I turned back and Tiddles had gone to sit in the middle of it.'

Opposite: TIDDLES WITH LEGS CROSSED, c. 2008
Page 51: KITTY DRINKING MILK, 2007/08

THE CATS

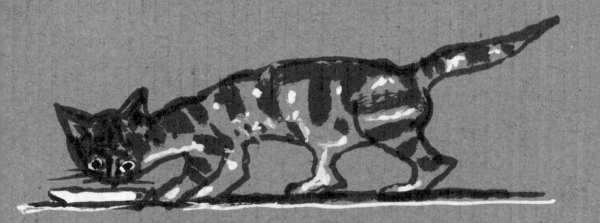

TWO CATS, 1955—57

As with many of Craxton's subjects, there are different versions of this image. I can think of a conté-and-charcoal drawing with the same title and a tempera on paper, both done in 1955, and there may be others. The geometric stylization of fur and limbs is extreme in the drawing, but gentle here. This painting of two lean but friendly cats was made for the photographer Joan Leigh Fermor. Craxton had met Joan Eyres Monsell, as she was at the time, in London during the war, and she became a lifelong friend. In 1944, Joan met Patrick Leigh Fermor in Cairo and they fell in love, eventually marrying in 1968. So, when Craxton discovered Greece in the immediate post-war years and renewed his friendship with Joan, he also met Paddy, as he was universally known. Artist and author became great friends, and Craxton was the obvious choice when Paddy wanted someone good to design covers for his books. Their partnership resulted in a series of memorable designs.

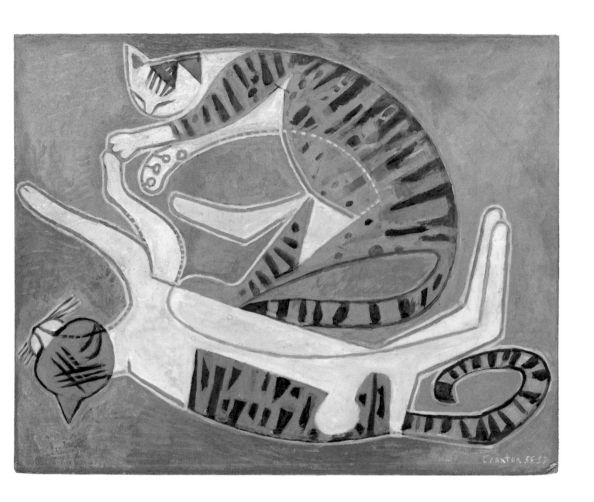

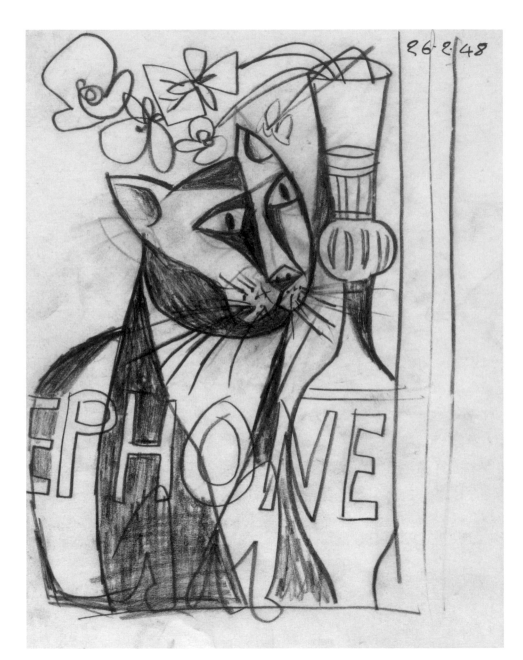

26.2.48

Opposite: CAT AND TELEPHONE, 1948

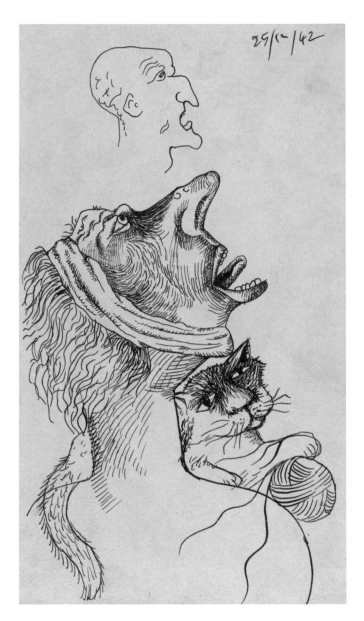

29/12/42

CAT WITH BALL OF WOOL, 1942

A delicately worked pen drawing
referencing the Northern Renaissance, and
the kind of imagery to be found in the work
of such artists as Hans Baldung Grien and
Dürer, with a nod to Leonardo's grotesques.

CAT BOWL, c. 1952

Over the years, Craxton decorated various
plates and bowls, some with his friend
the potter Ann Stokes. This cat bowl was
probably made in Greece, at the same time
as a plate with a boy's head on it, which is
dated 1952. 'It's coarse pottery,' says Riley.
'I imagine he did it at a local workshop.
He did some lamps in the fifties too.' The
drawing of the cat is very accomplished,
fluid and economic. Is it a black-faced
Siamese, or a Cretan alley cat? No matter,
it is virtuoso work: a marvel of assured
linearity. The cat's features are drawn into
the paint, scored into the plump black circle
that is its face. Craxton has made another
clever and effective piece of design, born
of loving familiarity with the subject, and
showing him in complete command of the
means employed.

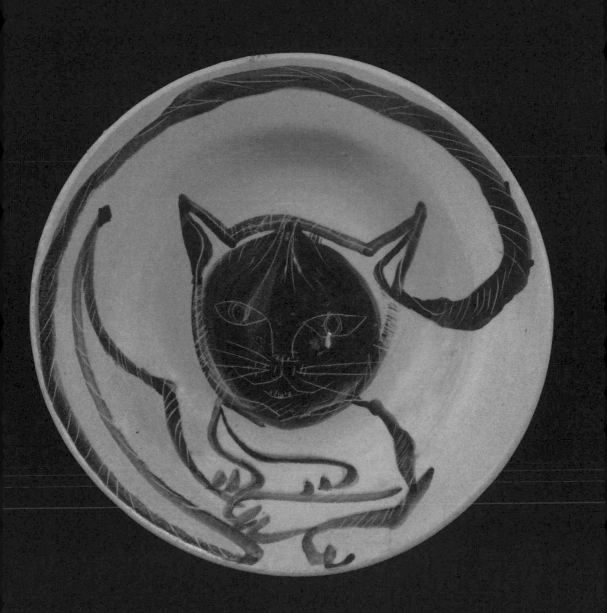

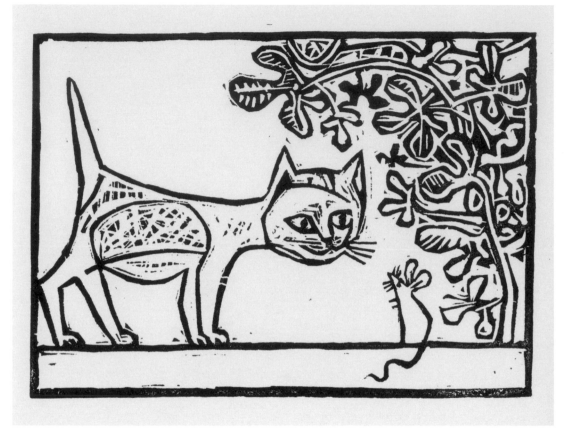

'Cats permeate Craxton's art, weaving their way through his paintings, drawings and prints, bringing humour and mischief to his images as they did to his daily existence.'

CAT AND MOUSE UNDER A FIG TREE, 1957

Overleaf: COCKEREL AND CAT, 1957

Cockerel and Cat presents one of those confrontations that regularly take place in nature between two fairly equally matched adversaries. Will it be a stand-off? Will each retreat with dignity intact? Or will it be an unseemly and potentially dangerous struggle that could go either way? Craxton has deftly caught the moment when everything is still up in the air, the pre-action manoeuvring.

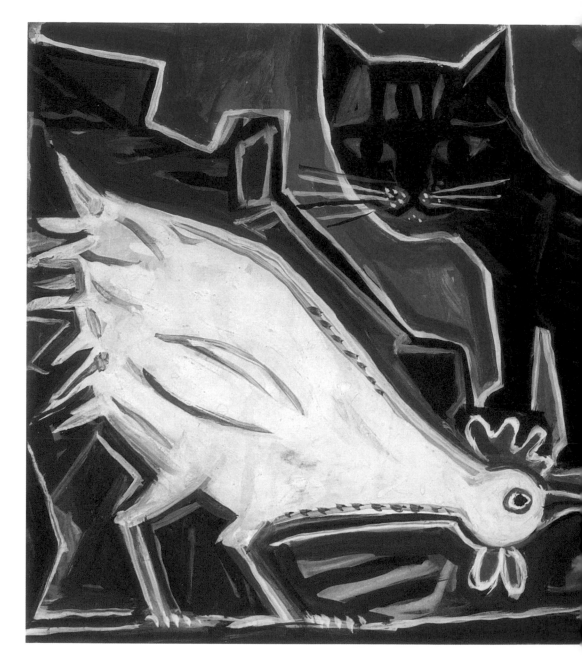

Ariane · with love ·

·Craxton·57·

CAT, 1958

The subject of *Cat* is one of those naughty felines, irresistibly attracted by the smell of fresh fish, that is about to raid a lunch table while the host is away. Craxton has caught this one in the act: wonderfully elongated, at full stretch to reach the prize. It looks at us with wild surmise, drooping a disarmingly foppish forepaw. The same pose reversed appears in the Tate's painting of the following year, *Still Life with Cat and Child*, in which the tempting tabletop spread of lobster and squid appears vast in comparison to the trespassing moggie. This superb piece of design is a minor masterpiece, a high point among Craxton's cat pictures.

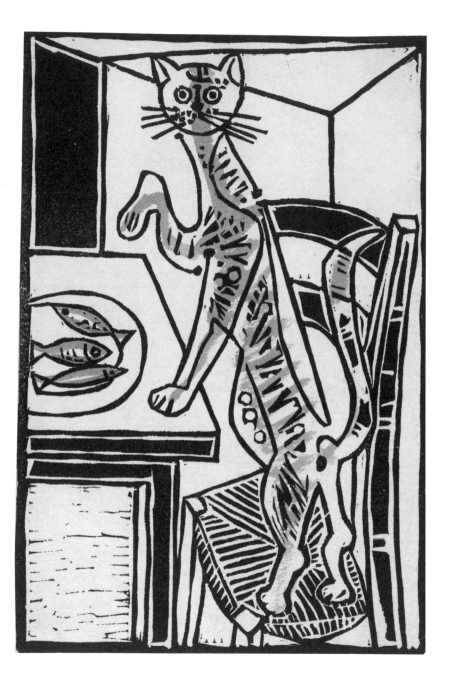

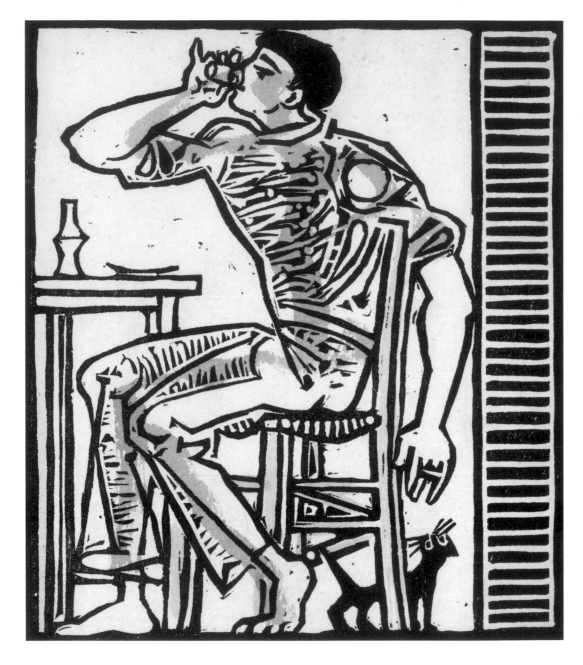

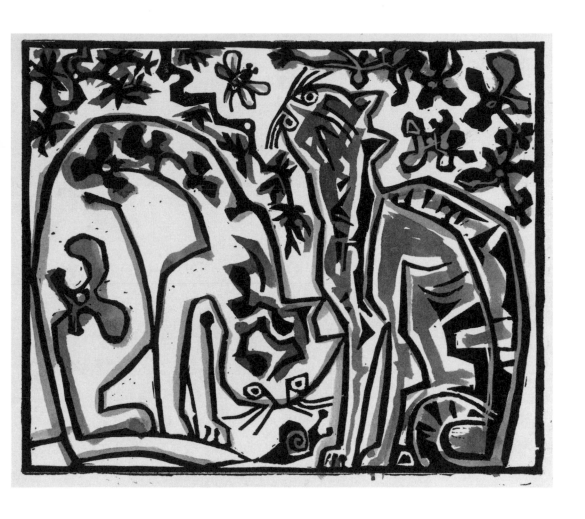

Above: CATS AND INSECTS, 1964
Opposite: DRINKING BOY AND KITTEN, 1960

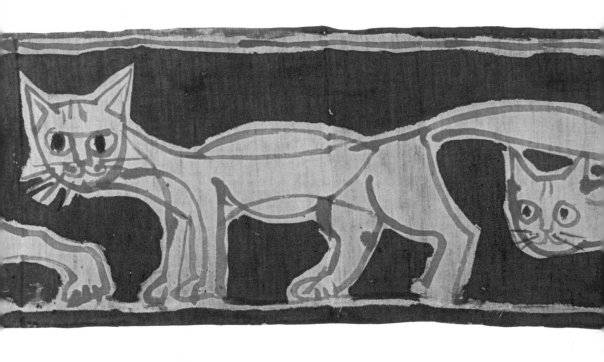

CAT LAMPSHADE, late 1950s/early 1960s

Cat Lampshade was painted and drawn on some kind of linen. Now very fragile, it and its companion pieces (there is one of crayfish) were dismantled, restored and framed flat. As Richard Riley says, it looks as if John 'dashed them off. He could turn a canvas, with a pen or a brush, very quickly into something. He had that sort of knack and imagination. And probably lunch was on the table so he thought, "Oh, better get it done and then I can go and eat!" He was very fond of his stomach.'

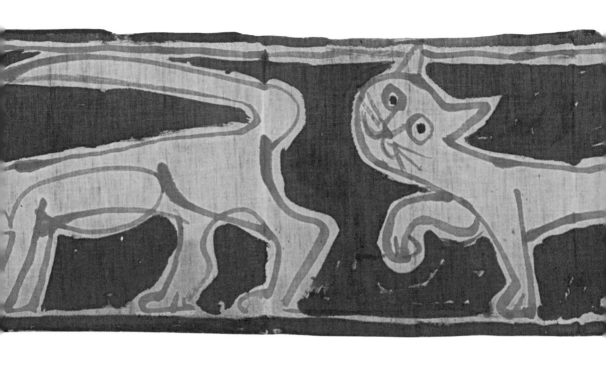

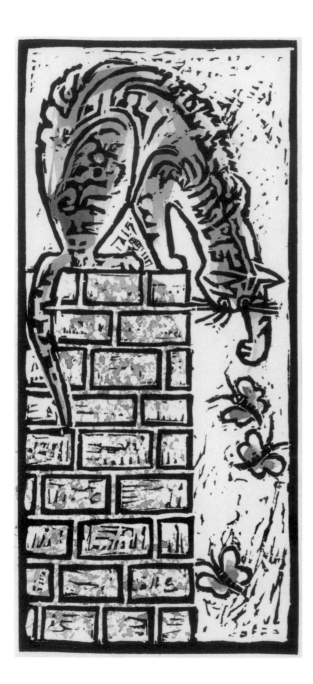

CAT AND BUTTERFLIES, 1960s

Opposite: SYLVESTER, 1970

Michael Astor owned Bruern Abbey and was a good friend of Craxton's. Sylvester was an Astor family cat, and the drawing was done at Bruern. The name Sylvester, shared between cat and a famous art critic, looks as if written in Lucian Freud's childish hand, but was actually inscribed by one of the Astor grandchildren. The cat itself looks angry: his fur is standing on end and his tail all fluffed up. Evidently his local humans have not been behaving themselves properly.

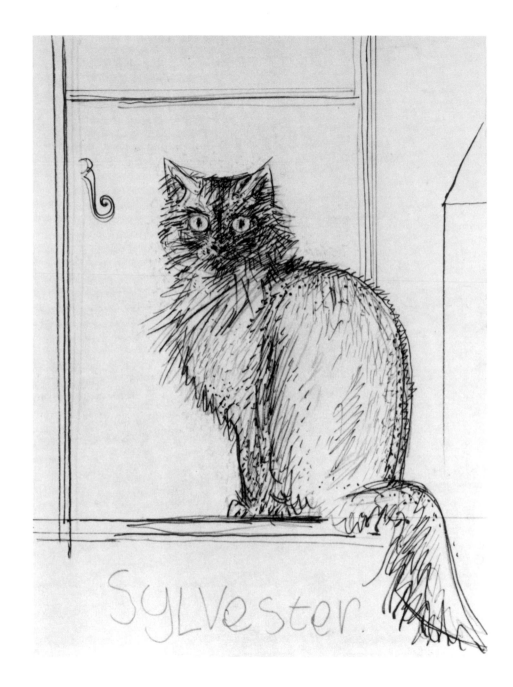

Sylvester.

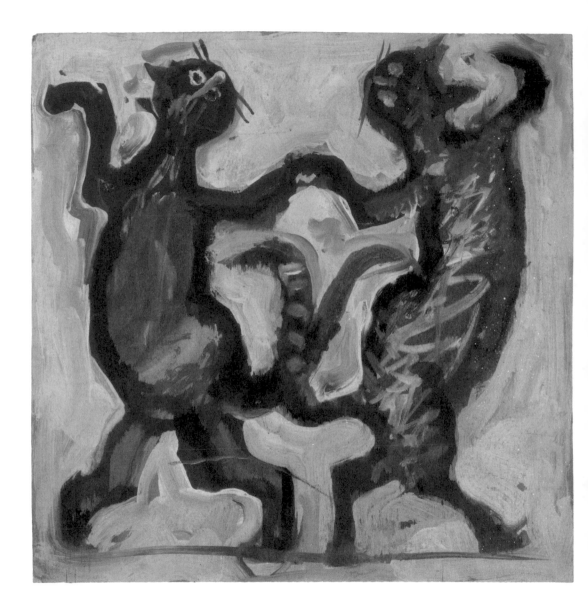

'For all his gregariousness, Craxton was also the cat who walked by himself. He was deeply individual, an independent artist who painted precisely what he wanted to, even when he undertook a commission.'

DANCING CATS, 1970s

Opposite: CAT AND STEEPLE, 1970s

Richard Riley identifies the steepled building in the pencil part of this drawing as an echo of Craxton's designs for the dust jacket of *A Time of Gifts*, Patrick Leigh Fermor's bestselling travel book published in 1977. Perhaps these were Craxton's first thoughts that were later developed into the image of a hiker surveying the prospect from a high vantage point. This drawing, a typical example of Craxton picking up a piece of paper and reusing it, is also a rather subversive image. Consider the scale alone: an enormous puss braces her shoulders against the ledge dividing her from those pencilled buildings, rather like Godzilla threatening a modern city.

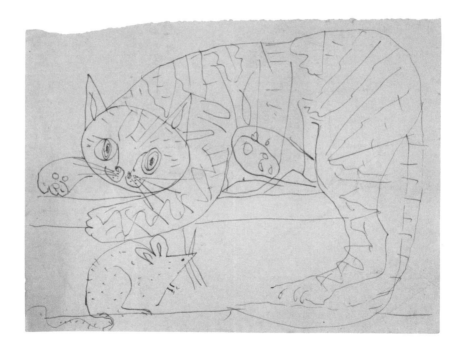

CAT AND RAT, 1970s

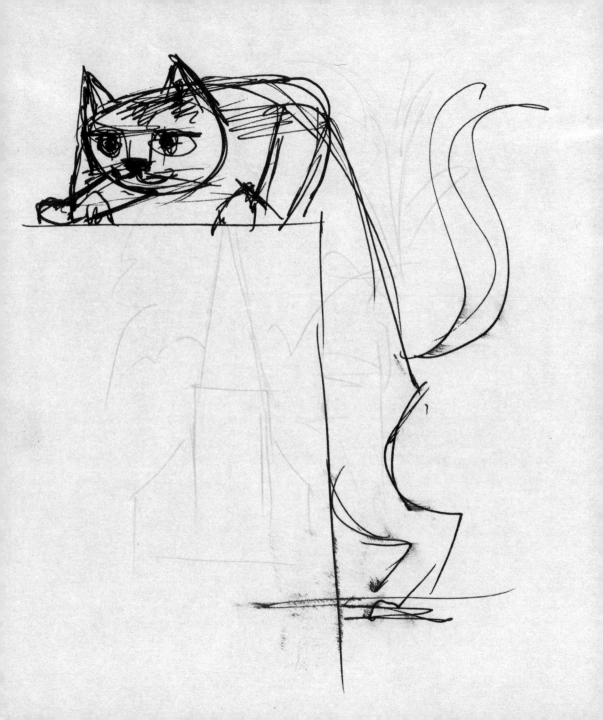

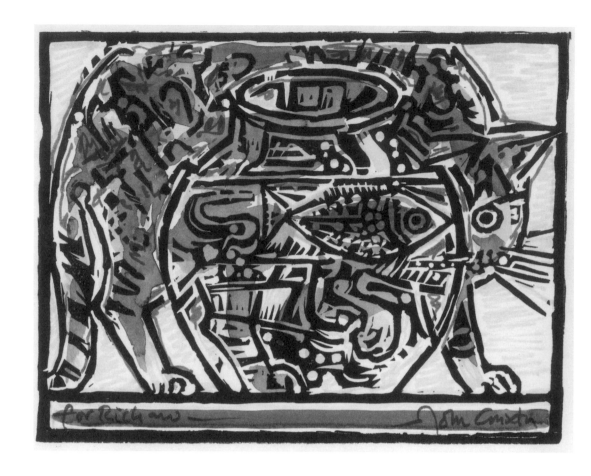

CAT AND GOLDFISH, 1975

Cat and Goldfish is a particularly resplendent example of Craxton's hand-coloured linocuts. The late cat prints were often digital prints similarly coloured. There are all sorts of possible sources for these images. Richard Riley lists a few: 'John might have seen a goldfish somewhere, or a nineteenth-century print might have caught his eye. Or he might have invented it. Big glass balls on pedestals with candles behind were helpful to people making lace. He knew about them. Or he'd see an actual cat doing something and he'd think, "Ah yes, there's another picture." That was how he worked.'

CONFRONTATIONAL CATS, 1977

The linocut *Confrontational Cats*, a rare uncoloured example, offers a very interesting occupation of the picture space. It's as if the two cats are boxed in by the picture edges, and Craxton cleverly uses these lines to contain the shapes of the bodies, rather than cropping them as a camera would. This is also a striking example of Craxton's deep preoccupation with linear pattern, which draws at least part of its energy from the Celtic tradition of ornament.

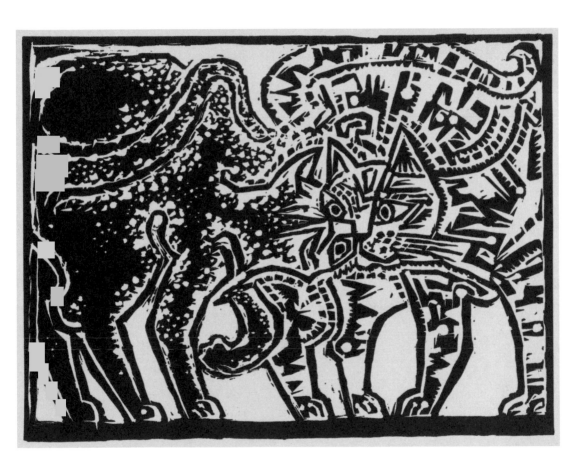

British Embassy Cat wittily utilizes the headed notepaper from the British Embassy in Athens, building the cat ingeniously around the embossed crest, which, with the addition of some whiskers, becomes its face. (This is reminiscent of a New Year's Eve letter that Craxton sent to his friend and fellow cat-lover EQ Nicholson in 1942, the writing filling a large outline head of a cat he'd drawn.) The other stationery drawing is *Pencraft for Parker Cat* (below), of the same period. Allied in theme is the later *Pussy Postage Stamp* (2008; page 138), addressed to Mister Riley at 14 Kittie Paw [for Kidderpore] Avenue, in which a full-face cat usurps the queen's place on the stamp. A cat may indeed be a queen. The puns reverberate.

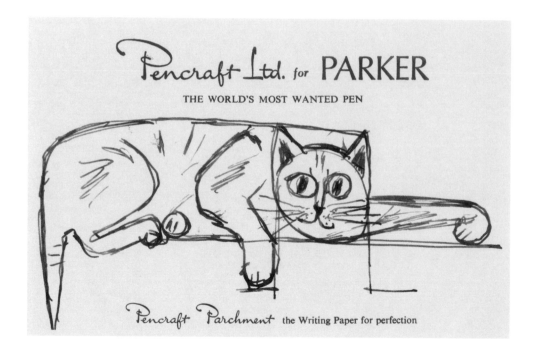

PENCRAFT FOR PARKER CAT, 1970s

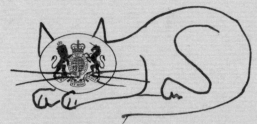

Fri night dinner 5 hikas

Sat Clement offices
lunch Taverna
walk on hills.
dinner 5 hikas
visit studio

Sun flea market mon
lunch here
Acropolis aft.
dinner
Barry Lyndon.

Mon

Barbara
Barbara
Barbara

SMUDGE BEGGING, 1978

In *Smudge Begging*, the big blocky form of
Smudge makes him look like a bullyboy of
a cat, but Riley describes him as not nearly so
massive as Tiddles. Here he is shown sitting
up on his haunches. This painting, in acrylic
on board – as were so many of Craxton's later
works – was a birthday present to Riley, who
was particularly fond of the cat. 'Smudge was
adorable,' he says. 'He really was.'

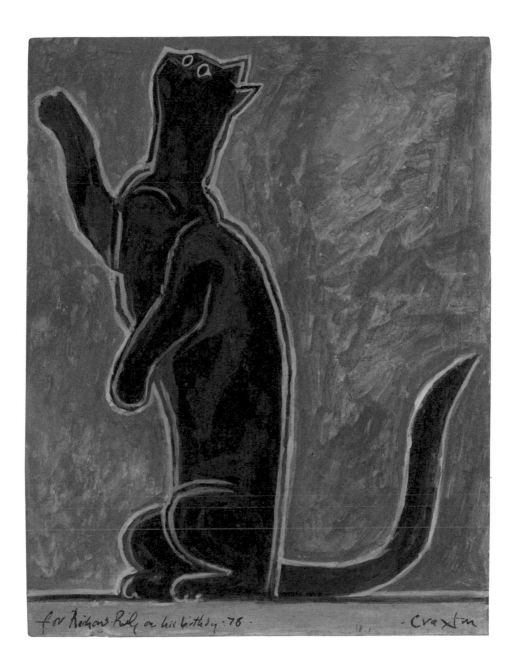

for Richard Riley on his birthday -78 . -Craxton

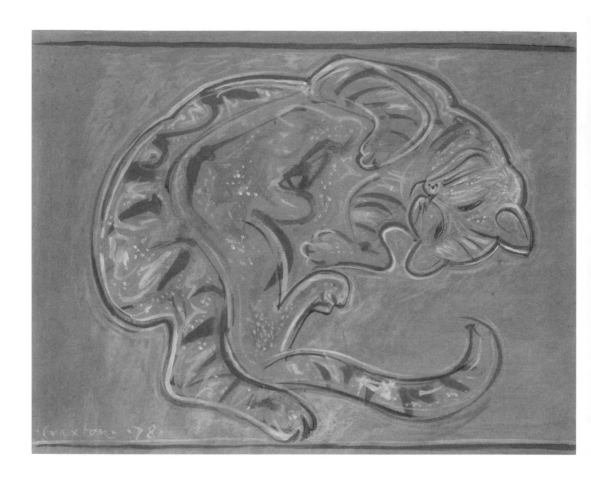

'Cats were very much part of John's life.
I think he loved the fact that a cat came and
curled up on your knee, or snuggled up to you.'

RICHARD RILEY

SLEEPING CAT, 1978

Richard Riley recalls: 'Somebody rang up and would like a little present for a friend. John took *Sleeping Cat* down to the lady and she said, "Oh, I didn't want a cat! No, I wanted a landscape!" And she'd already said, "I don't want to spend more than £50." So John went off with a couple of landscapes for her to look at and she said, "Oh I don't think I want to pay more than £35 for that," then started to write a cheque. John said, "For this amount of money, I want cash." And this was someone who had plenty of dosh! So I gave John £50 for the cat and there was a drawing for this picture that turned up at Bonhams about ten years ago, and it was put in the sale at about £6,000 to £8,000. A pretty good return on £50.'

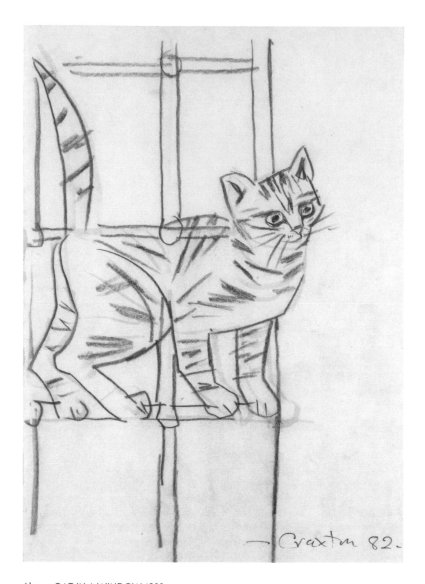

Above: CAT IN A WINDOW, 1982
Opposite: CATS ON A LADDER, 1984

for Rithard
with
love
&
best
wishes

JM.
-1984-

LANDSCAPE WITH CAT AND BIRD, 1987

Landscape with Cat and Bird is one of the puzzle pictures Craxton enjoyed painting so much in his later years. The cat is easy enough to spot in the bottom left-hand corner climbing up the tree, but where is the bird? Every branch-divide begins to look like the feathered prey ... Similarly in *Cat and Butterfly* (1988; opposite).

CAT AND BUTTERFLY, 1988

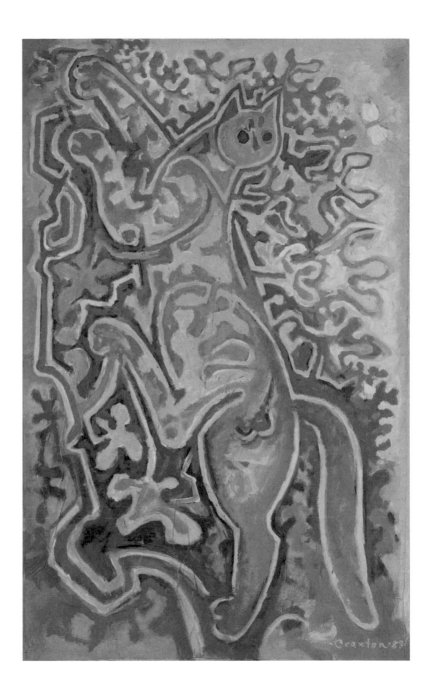

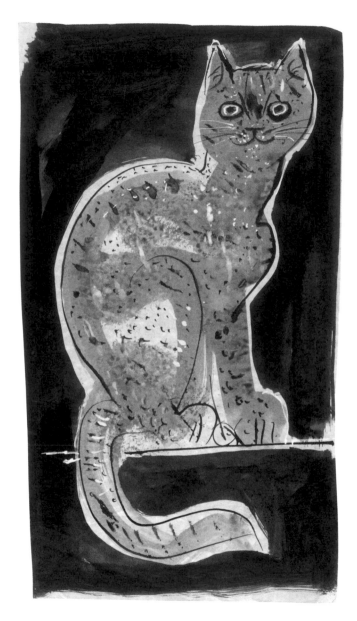

HAPPY CAT, 1980s

Opposite: **SUPERCILIOUS CAT**, 1980s

The feline in *Supercilious Cat* at first appears to be rather cross, its back arched and its hefty tail swishing in anger, but the mood softens as you look at it. The blackness of the image is everywhere lightened with grey wash and touches of white, which animate the composition and the animal's pose.

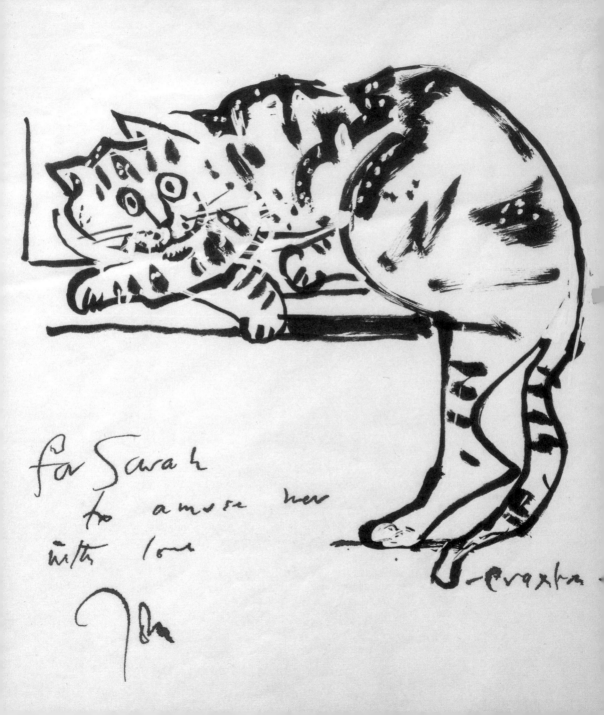

for Sarah
to amuse her
with love

John

revexta.

For Sarah to Amuse Her is a typical quick
sketch given to a friend. The pose is beguiling,
with the extended lazy back leg slipping
down to another level. (Perhaps the cat is
lying on the stairs?) Here the interest is all
in the expression: slightly soppy and almost
cross-eyed, the kind of look that certain cats
do give their owners or admirers.

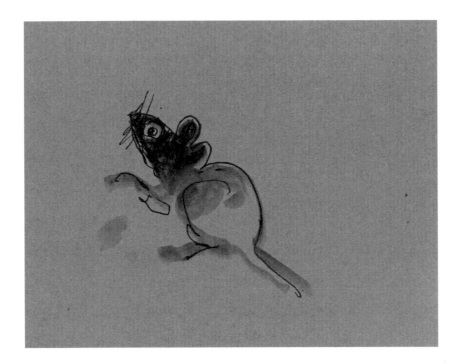

MOUSE, 1980s

'Craxton never set out to have a cat as a pet; instead, he tended to adopt them. Or else they simply found him, and stayed.'

MARAKI, 1990s

'Meraki' in Greek means doing something carefully with a sense of pride; it could be translated as 'labour of love'. This cat has been drawn with care and love. It is a more traditional portrayal and achieves a solidity not always present in Craxton's lithe and playful moggies. Maraki has dignity and wants us to know it.

Pages 92–93: CAT STEALING FISH, 1990s

MADAKI

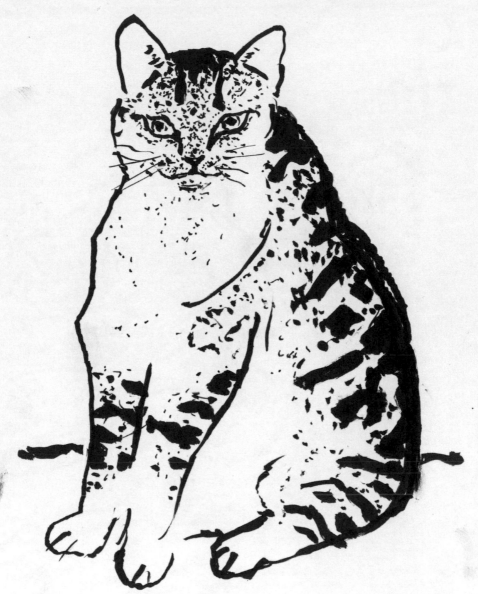

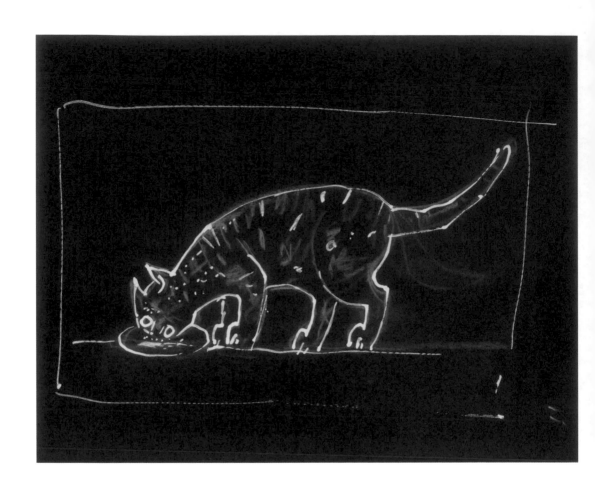

Above: CAT WITH TWO TAILS, c. 1992
Opposite: BLACK AND WHITE CAT, 1992

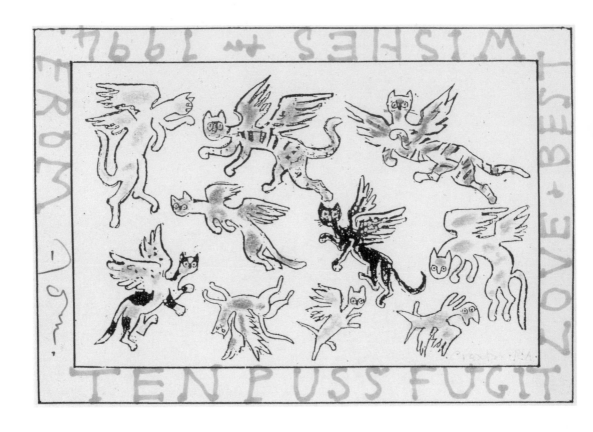

TEN PUSS FUGIT, 1994

Ten Puss Fugit, which became a Christmas/
New Year card in 1994, started life as the
decorated lid of an old shoebox given as
an 80th birthday present to EQ Nicholson
in 1988. In its Christmas card incarnation,
it was later reproduced, along with a couple
of other Craxton cards, in *A Gentleman
Publisher's Commonplace Book* by John

G. Murray (1996). 'Jock' Murray was a
friend, and of course the publisher of all
Patrick Leigh Fermor's books with Craxton's
striking dust jackets and illustrations. This
design is one of the corniest of Craxton's
puns given unforgettable visual expression:
ten winged cats become the cipher for the
Latin exclamation *tempus fugit*, or 'time flies'.

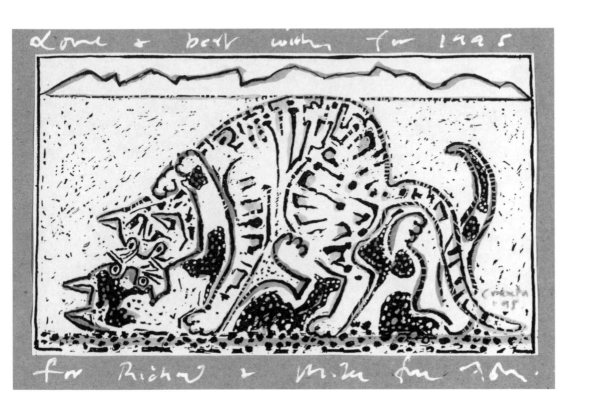

FROLICKING CATS, 1995

MARMALADE CAT IN MIRROR, 1994/95

This surreal image of a one-eyed beast like
the infamous giant Cyclops, looking at
itself in a mirror, is strangely disconcerting.
But maybe we can see only one eye of two,
because of the angle from which we are
looking. Craxton has certainly ameliorated
the oddness with his joyful decoration: this
cat's coat is orange with green spots, and is
framed in red, blue and gold. Sumptuous.

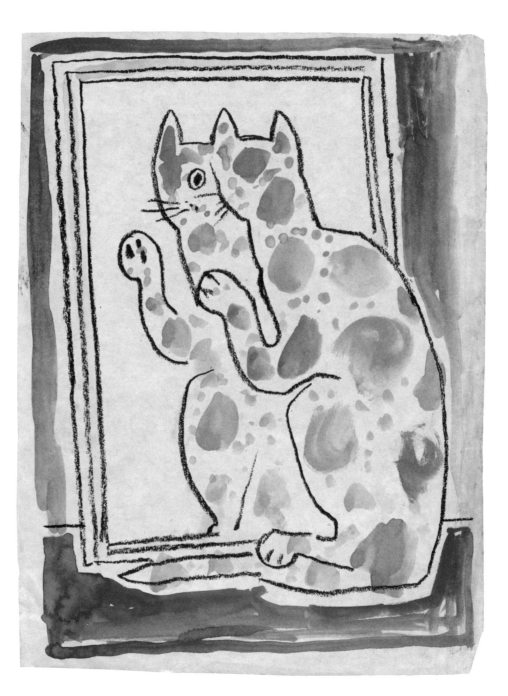

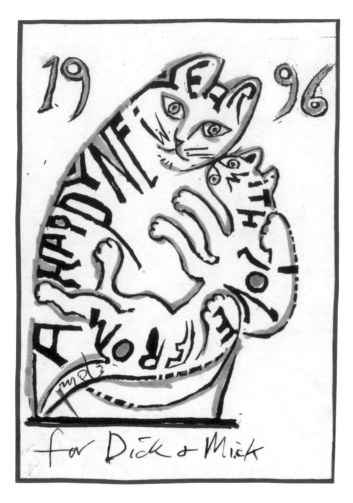

HAPPY NEW YEAR, 1996

The greeting 'A HAPPY NEW YEAR WITH LOVE FROM' is both script and the markings on the coat of the green-eyed cat and her kitten, with the added witticism of the 'EAR' of 'YEAR' coinciding neatly with the mother cat's pricked ears. As the text outlines the kitten's body, it also follows the logic of form and turns upside down. And as a further witty touch, Craxton signs 'John' upside down too.

Opposite: CATS AND CHAIR, 1997

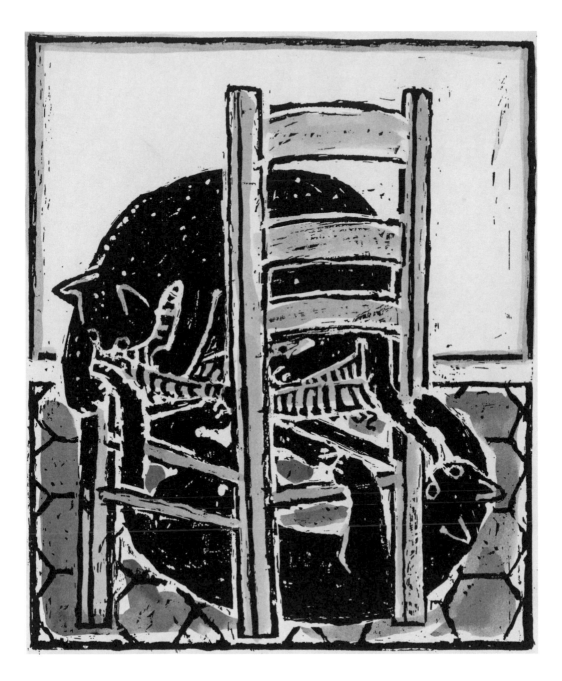

'Painting is a very strange art because it's a combination of emotional intuition and learning and wisdom and experience.'

JOHN CRAXTON

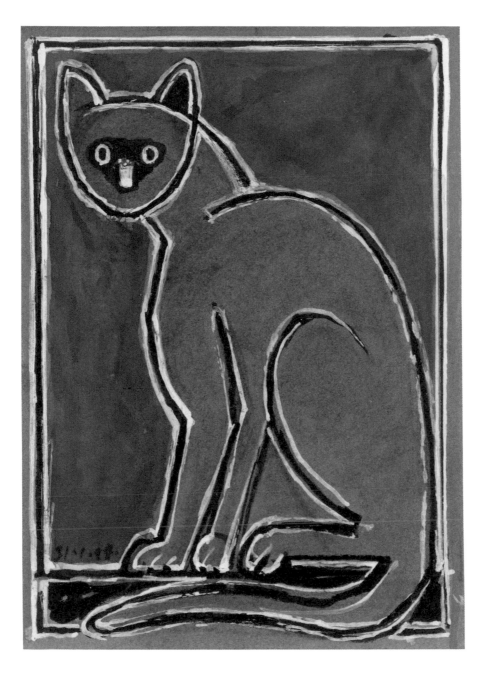

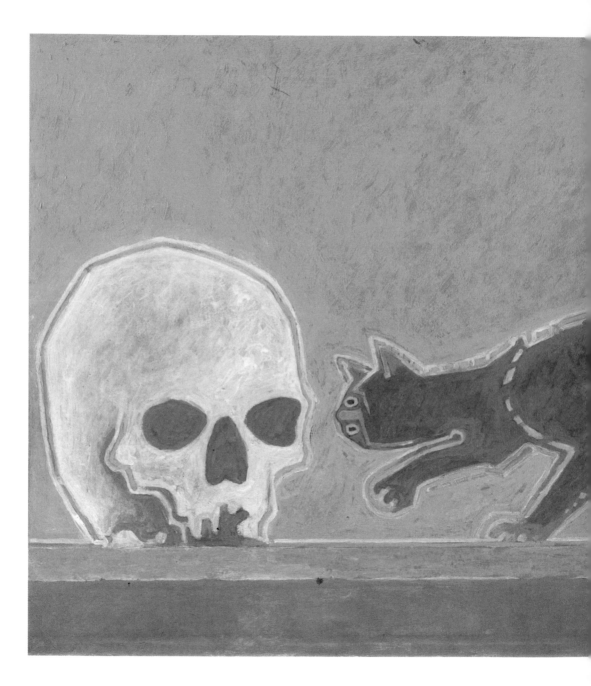

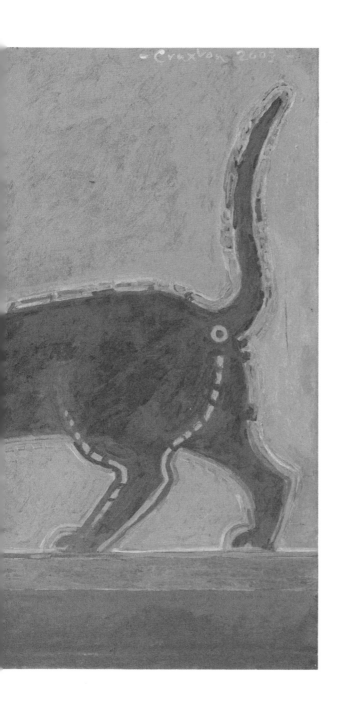

CAT AND SKULL, 2003

Cat and Skull, a light-hearted memento mori, clearly contains a reference to Andy Warhol's *Skull* paintings, particularly apparent in the use of colour. Interestingly, the Christmas card design featuring this image predates the painting by a year. This was sometimes Craxton's method of working: to try out an idea first in a Christmas print and then elaborate it into a painting. Or perhaps the idea had simply been in his mind for some time, and surfaced occasionally. Certainly, the image that became Craxton's Christmas card for 1997, *Cats and Chair* (page 101), did not emerge as a tempera painting until 2003.

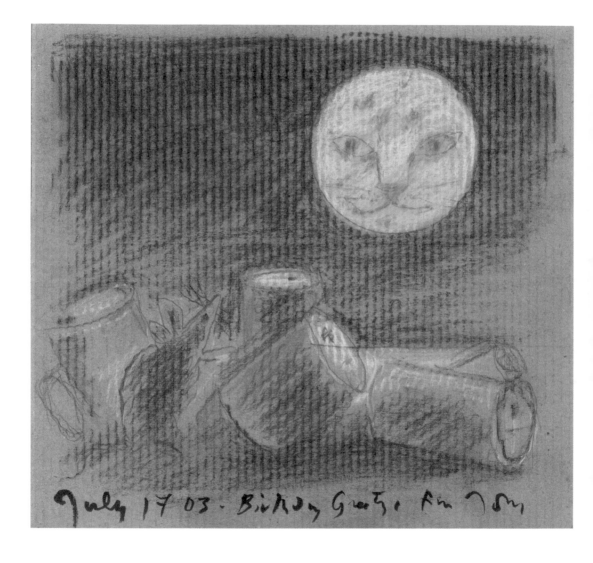

July 17 03 · Bishop Grethe for Tom

MOON CAT: BIRTHDAY GREETINGS, 2003

Moon Cat: Birthday Greetings, made for Richard Riley, looks like something by Odilon Redon in his proto-surrealist phase. A cat-faced moon glares balefully down on a rat cowering among an array of empty cans. This is not so much a comment on alcoholic consumption as a reference to Riley's habit of collecting tin cans and then selling them. Although the metal was worth only 35p or 40p a kilo, he collected so many binbags full of aluminium cans over a number of years (from the late 1990s until 2005) that he made enough money to fund a holiday. There was a certain satisfaction in it too, clearing up some of the worst of London's litter.

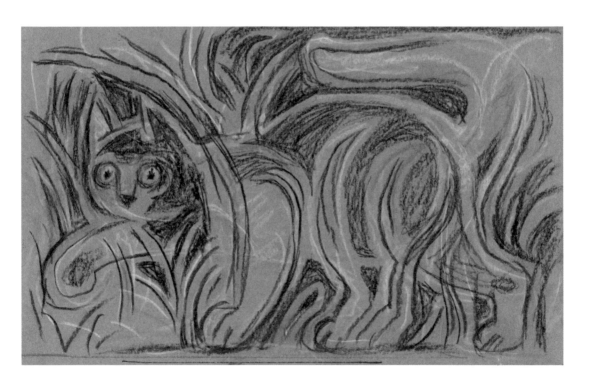

Above: JUNGLE CAT, 2004/05

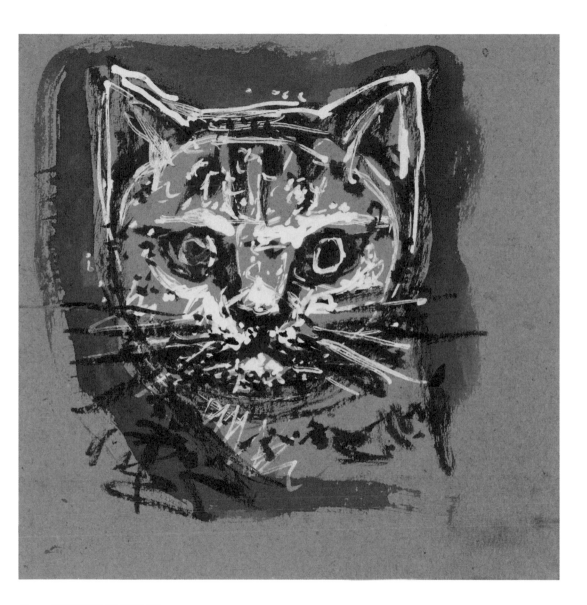

Above: CAT PORTRAIT, 2005/06
Opposite: THE LAST SUPPER, 2005/06

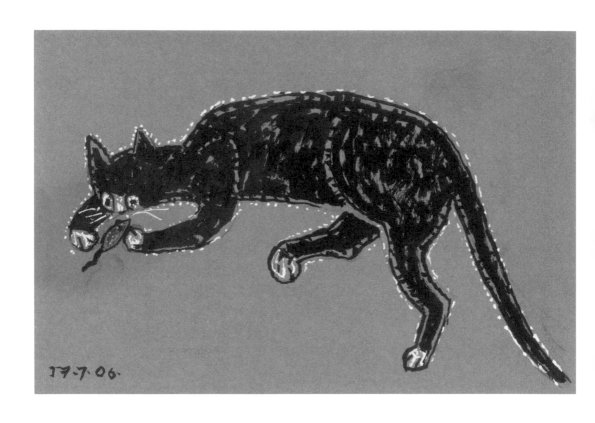

CAT PLAYING WITH MOUSE, 2006

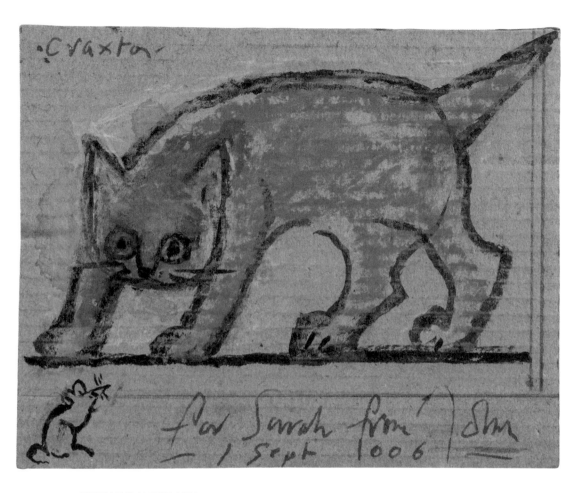

KITTEN AND MOUSE, 2006

Kitten and Mouse, in mixed media, humorously reverses the usual roles: an unwary kitten, happening for the first time across a mouse, draws back in fear and trepidation, spine arched and tail stuck straight out. This masterpiece of body language contrasts effectively with *Cat and Ant* (2007; pages 120–21), in which an older animal investigates a large insect and is caught in mid-gesture, paw upraised. Will it bat the unfortunate creature about, as it would torment a mouse before killing it, or will it be stung for its pains? As usual, Craxton identifies the critical moment of confrontation before resolution.

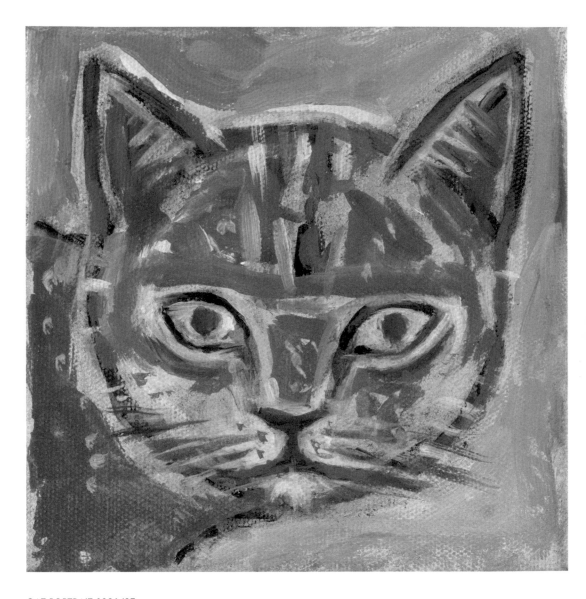

CAT PORTRAIT, 2006/07

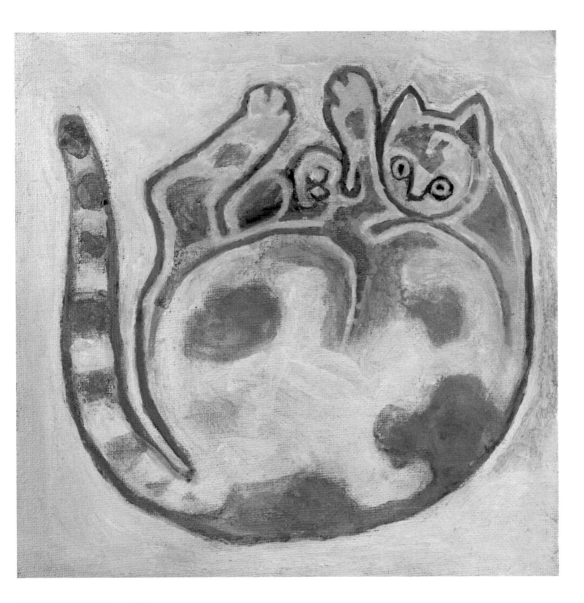

ROLLED INTO A BALL, c. 2006

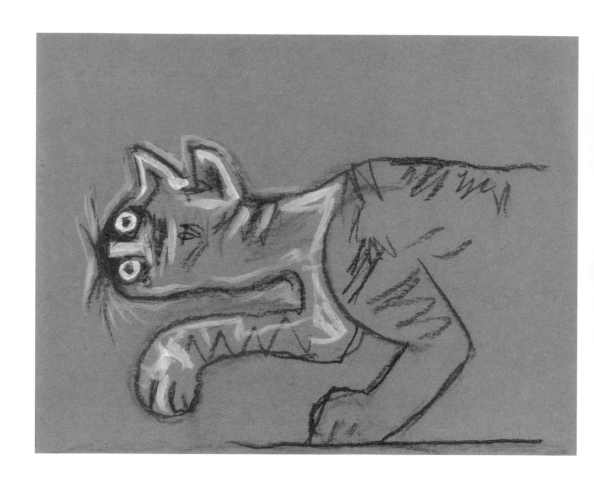

CAT HUNTING, 2006/07

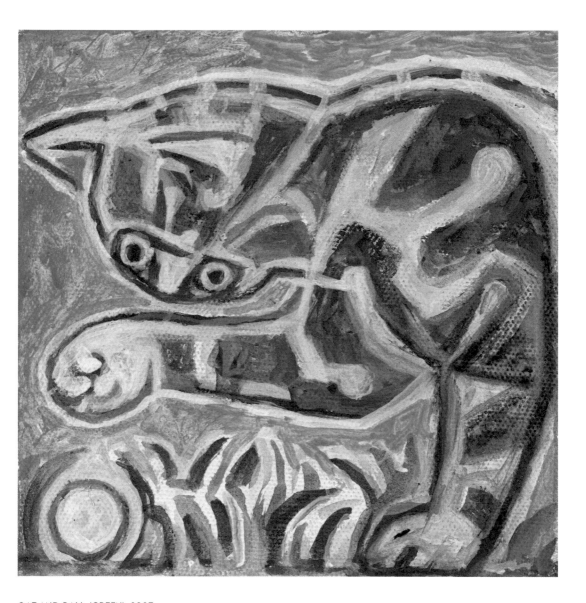

CAT AND BALL (GREEN), 2007

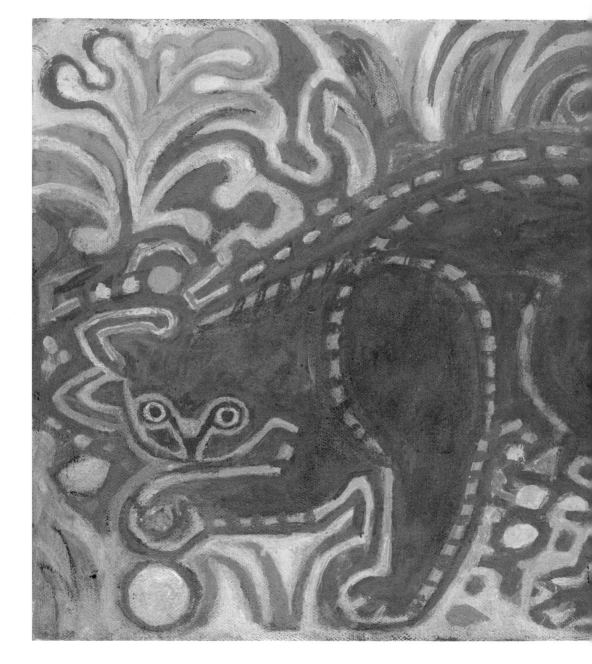

CAT AND BALL, 2007

CAT AT A MOUSE HOLE, 2007

Any piece of card or offcut of board that
was to hand would be pressed into use, and
Craxton would often play upon their chance
features of size or shape. The mouse hole
here is a pre-existing semicircle mechanically
cut from the cardboard on which Craxton
painted – a typically witty touch.

Pages 120–21: CAT AND ANT, 2007

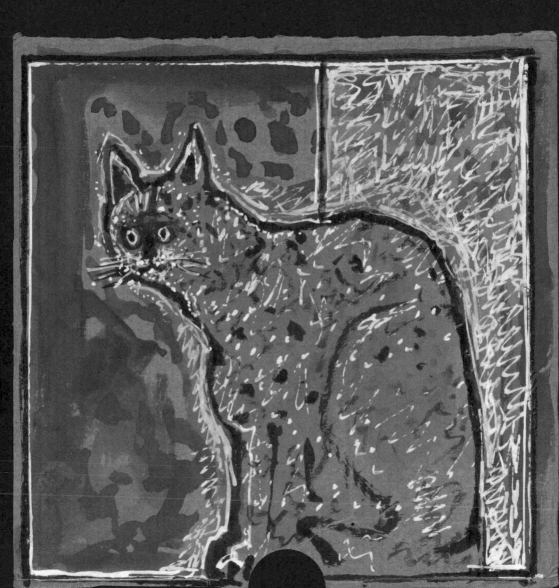

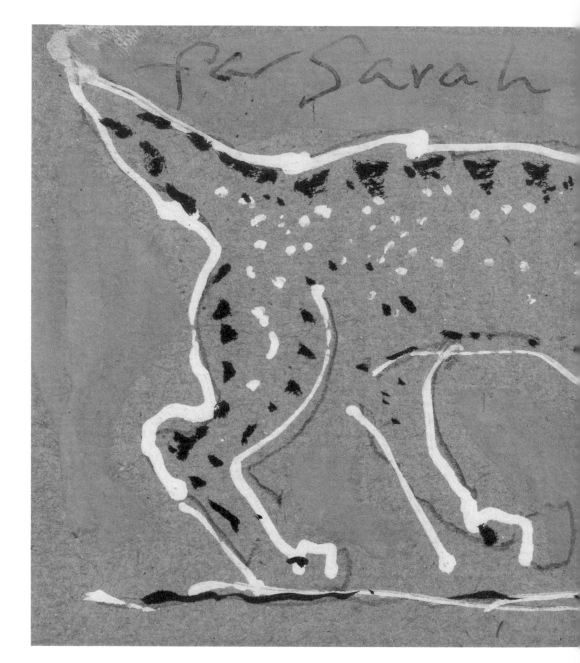

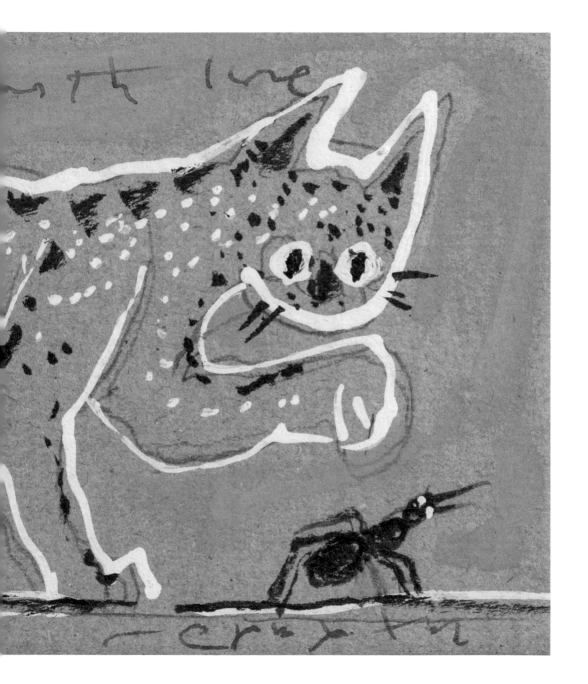

'Craxton was so familiar with the vocabulary of cat moves, gestures and stances that he could capture them with utter conviction in a few strokes of the pen or brush.'

ALLEY CAT, 2007

This alley cat is clearly a bit of a bruiser – witness his slightly punch-drunk expression – and has lost most of his tail in a fight. Craxton's cats tend to be domestic rather than feral, but there is an undeniable fierceness to some of his moggies: they can be formidable, even frightening. Perhaps not quite as terrifying as the merciless feline in Picasso's *Cat Devouring a Bird* (1939), which rips the fowl asunder with sharp claws and ferocious teeth. But nevertheless, this is a cat to be reckoned with.

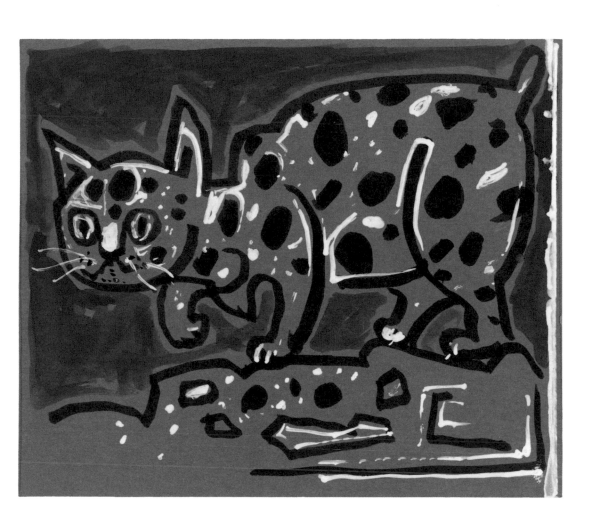

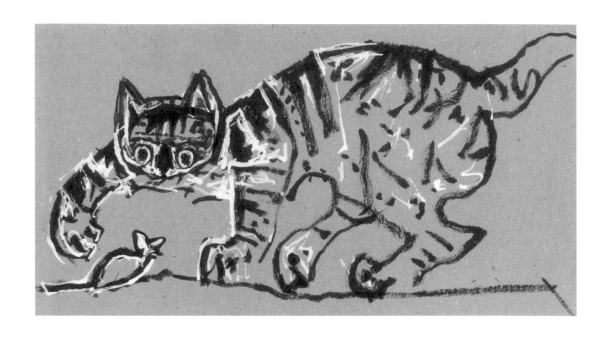

CAT AND MOUSE, 2007

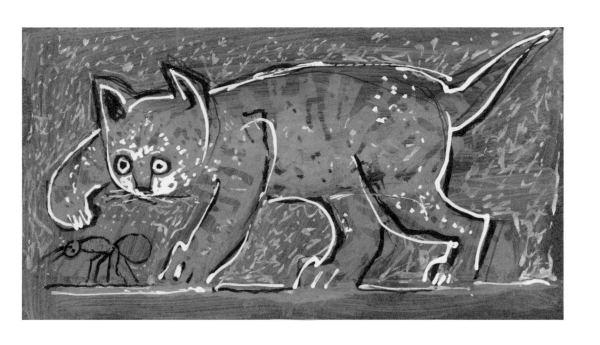

CAT AND ANT, 2007/08

STAND-OFF OVER A FISH, 2008

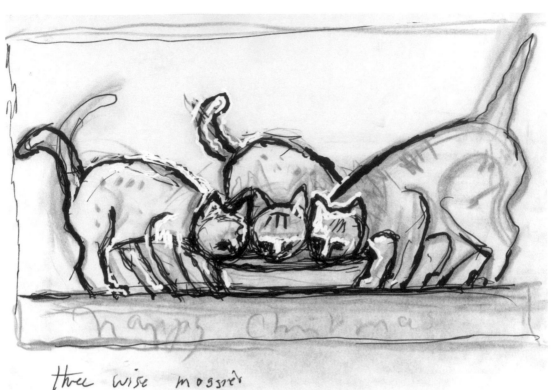

three wise moggies

THREE WISE MOGGIES, c. 2007–08

Three Wise Moggies, in which all three cats are feeding from the same bowl, is one of a number of studies for a Christmas card that make overt reference to the Three Wise Men in the biblical narrative of the Nativity. Probably done from imagination rather than observation, and typical of Craxton's urge to pun, this image has moved a step nearer to parody than the early drawing of the cat and kitten with its covert Mother and Child allusion (page 12). Craxton was not above aiming a shaft of wit at Christianity, as he did in his 2008 Christmas card of the Madonna on a mobile phone, bearing the speech bubble 'I am with Child'. But his work is not generally satirical, being gentler and more amiably amusing in tone.

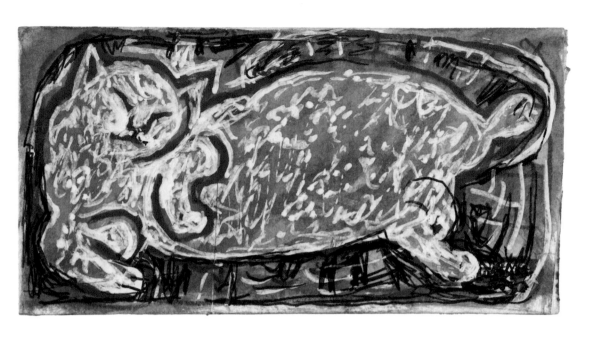

CONTENTED TIDDLES, 2008

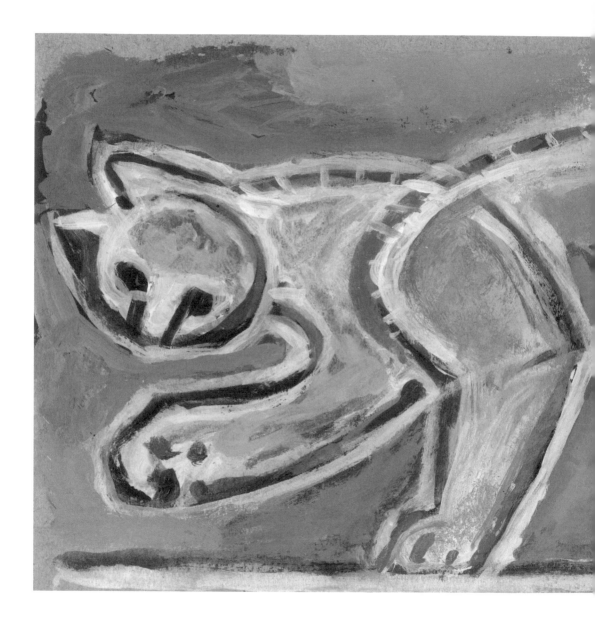

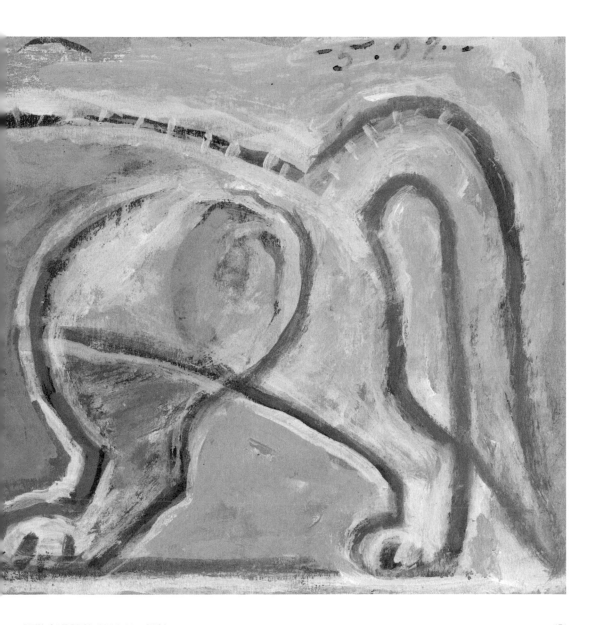

PINK CAT PROWLING, May 2008

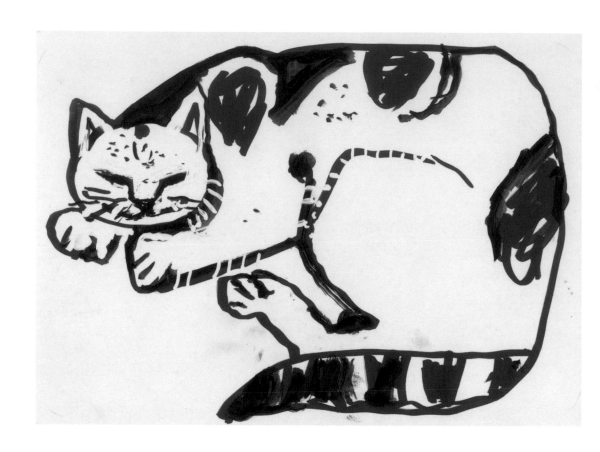

TIDDLES, c. 2008

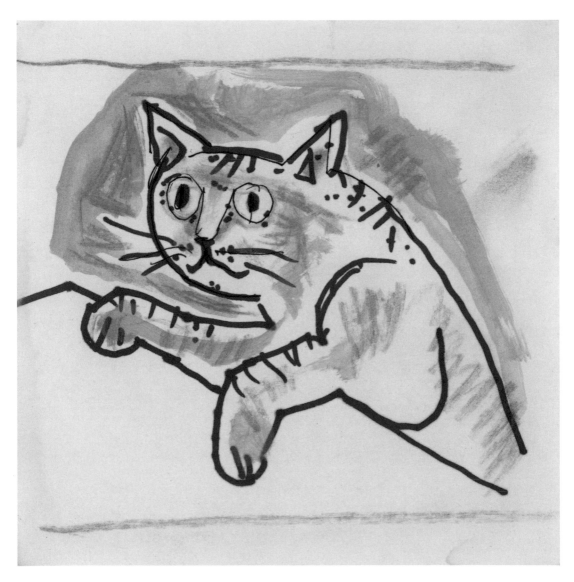

CLIMBING CAT, 2008

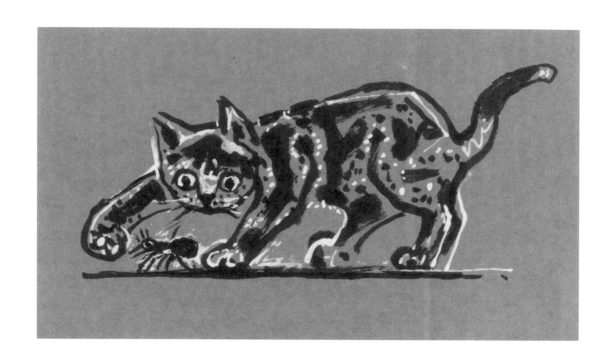

KITTEN AND ANT, 2008

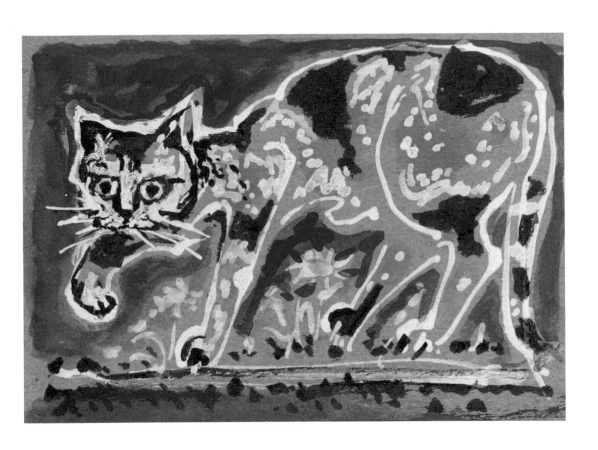

WORRIED CAT, 2008

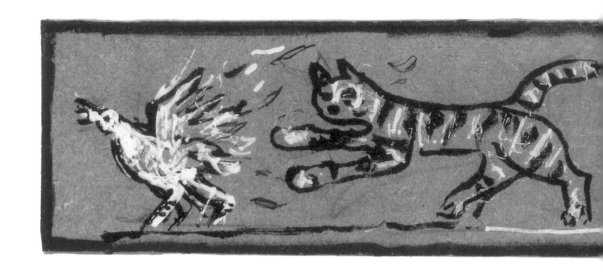

THE CHASE, 2008/09

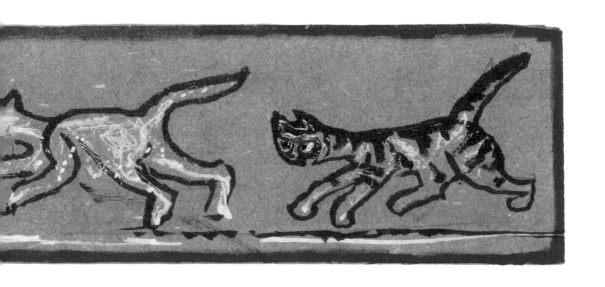

137

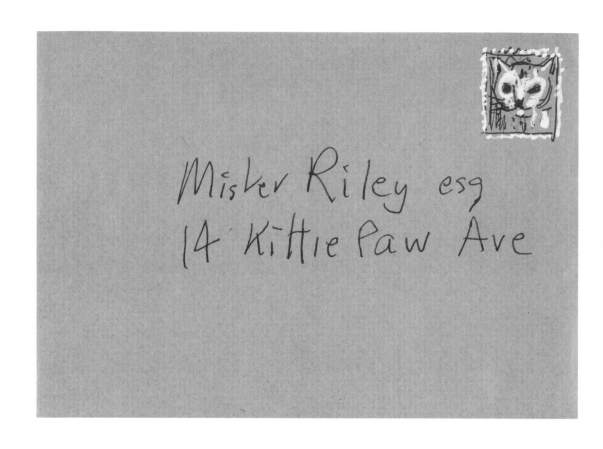

PUSSY POSTAGE STAMP, 2008

LIST OF ILLUSTRATIONS

My principal debt of gratitude is twofold: to John Craxton and Richard Riley. Their partnership was a remarkable one, and I pay warm tribute to it here. To John I owe much, not least the pleasure I get from looking at his paintings, drawings and prints. He was a great enthuser and inspirer, and I still benefit from his conversation. To Richard I am indebted for lengthy discussions about Craxton and his cats, for pertinent answers to all my questions, and for patience during the book's lengthy gestation. *Craxton's Cats* would not exist without his practical help and unwavering support. Mention should also be made of my wife, Sarah, a devoted cat lover, who has been a continual inspiration.

Every Craxton scholar is grateful for the extensive research carried out by Ian Collins, the artist's biographer. I would also like to mention those who have written with real understanding about Craxton's art: Bryan Robertson, David Attenborough and Geoffrey Grigson. Here follows a brief list of sources and possible further reading:

Geoffrey Grigson, *John Craxton: Paintings and Drawings* (London: Horizon, 1948)

Bryan Robertson, *John Craxton: Paintings and Drawings, 1941–1966* (London: Whitechapel Art Gallery, 1967)

Patrick Leigh Fermor, with an interview with John Craxton by Gerard Hastings, *John Craxton: An Exhibition of Paintings and Drawings, 1980–1985* (London: Christopher Hull Gallery, 1985)

David Attenborough, *John Craxton: An Exhibition of Portraits 1942–1992, Including Recent Work 1987–1993* (London: Christopher Hull Gallery, 1993)

Ian Collins, with an introduction by David Attenborough, *John Craxton* (Farnham: Lund Humphries, 2011)

Evita Arapoglou, ed., *Ghika, Craxton, Leigh Fermor: Charmed Lives in Greece* (Nicosia: A. G. Leventis Gallery, 2017)

Ian Collins, *John Craxton: A Life of Gifts* (New Haven, CT: Yale University Press, 2021)

David Attenborough *et al.*, *John Craxton: A Modern Odyssey* (Chichester: Pallant House Gallery, 2023)

Interviews with the artist recorded by Andrew Lambirth in 1998 and 1999 for the Artists' Lives project for National Life Stories. Recordings can be accessed at the British Library, London, and online at https://www.bl.uk/projects/national-life-stories-artists-lives.

ANDREW LAMBIRTH is a writer, curator and critic. He has written for a wide variety of newspapers and magazines, and was art critic at *The Spectator* from 2002 to 2014. The first book he worked on was Eileen Agar's autobiography, *A Look at My Life*, initially published in 1988 and recently reissued by Thames & Hudson. Among his other books are monographs on Ken Kiff, Roger Hilton, R. B. Kitaj, Maggi Hambling, John Hoyland, Margaret Mellis and John Nash. He lives in Wiltshire, surrounded by books and pictures.

PICTURE CREDITS

Unless noted otherwise below, all photos:
Todd-White Art Photography

6: © Anne-Katrin Purkiss
12: Peter J. Stone Photography
21: Tate, purchased with funds provided by the Knapping Fund 1995. © John Craxton Estate. Photo: Tate
26: John Craxton Photo Archive
30, 31, 34: Richard Riley Collection
60–61: Osborne Samuel Gallery, London
66–67: Osborne Samuel Gallery, London
82: Osborne Samuel Gallery, London
84: Osborne Samuel Gallery, London
85: Osborne Samuel Gallery, London
87: Nick Dunmur
88: Peter J. Stone Photography
111: Peter J. Stone Photography
120–21: Peter J. Stone Photography

Front cover: *Cat*, 1958 (see page 63)
Back cover: *Black and White Cat* (detail), 1992 (see page 95)
Page 1: *For Sarah to Amuse Her* (detail), 1980s (see page 88)
Page 2: *Cockerel and Cat* (detail), 1957 (see pages 60–61)
Pages 4–5: *Cat Lampshade* (detail), late 1950s/early 1960s (see pages 66–67)

First published in the United Kingdom in 2024 by Thames & Hudson Ltd, 181A High Holborn, London WC1V 7QX

First published in the United States of America in 2024 by Thames & Hudson Inc., 500 Fifth Avenue, New York, New York 10110

Craxton's Cats © 2024 Thames & Hudson Ltd, London
Text © 2024 Andrew Lambirth
Illustrations © 2024 John Craxton; see left for exceptions

Designed by Sarah Praill

British Library Cataloguing-in-Publication Data
A catalogue record for this book is available from the British Library

Library of Congress Control Number 2024934202

ISBN 978-0-500-02804-9

Printed and bound in China by C&C Offset Printing Co. Ltd

Be the first to know about our new releases, exclusive content and author events by visiting
thamesandhudson.com
thamesandhudsonusa.com
thamesandhudson.com.au